THE LIBRARY OF GRAPHIC NOVELISTS™

WILL EISNER

ROBERT GREENBERGER

The Rosen Publishing Group, Inc., New York

b3013691X

*To my parents, for giving me that first comic book
and encouraging me*

Published in 2005 by The Rosen Publishing Group, Inc.
29 East 21st Street, New York, NY 10010

First Edition

Library of Congress Cataloging-in-Publication Data

Greenberger, Robert.
Will Eisner/by Robert Greenberger.
 p. cm.—(The library of graphic novelists)
Includes bibliographical references and index.
ISBN 1-4042-0286-2 (library binding)
1. Eisner, Will. 2. Cartoonists—United States—Biography.
I. Title. II. Series.
PN6727.E4G74 2004
741.5'092—dc22

 2004016656

Manufactured in Malaysia

CONTENTS

INTRODUCTION

In 1983, I was editing *Comics Scene*, the first newsstand magazine to cover the comic book, comic strip, and animation industry. That summer, I was in San Diego, California, for the biggest comic-book convention in the United States. One afternoon, I was asked to replace another journalist who was scheduled to conduct an onstage interview—in just twenty minutes—with Will Eisner.

I had not met Will but certainly had read his works. He couldn't have been more gracious as we spoke just minutes before taking the stage. He was just releasing his latest book, *New York, the Big City*, so we chatted about that and a few other recent and past works, making the hour-long interview a smooth, memorable event. It couldn't have been a better hour. Eisner made it easy to talk to him. After all, he's a gifted storyteller.

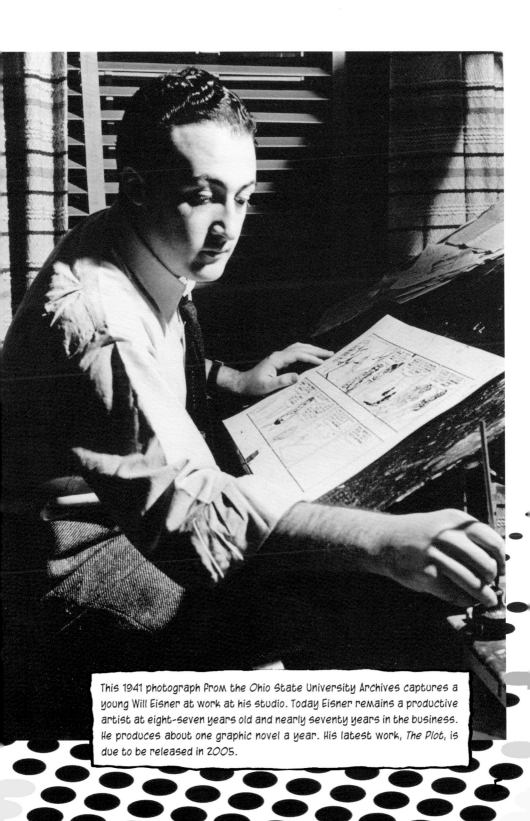

This 1941 photograph from the Ohio State University Archives captures a young Will Eisner at work at his studio. Today Eisner remains a productive artist at eight-seven years old and nearly seventy years in the business. He produces about one graphic novel a year. His latest work, *The Plot*, is due to be released in 2005.

Comic books as we know them are an original American art form, just under a century old. Eisner was among the first generation of artists and was perhaps the most astute, juggling not only a mature style, but learning how to be a businessman. He is a pioneer in his field: Eisner kept control over his most important character, the Spirit, and set the example for countless future artists. Today, the Spirit character is being made into a feature film by Odd Lot Entertainment. Due out in the near future, it promises to combine Eisner's original visual flair with a strong, character-driven plot.

Eisner is presently in his eighties, though he is just as productive as ever. He continues to explore issues that mean a great deal to him personally but also have universal relevance to readers around the world. In his Florida studio, Eisner has been working on the *Plot*, a book described by the *Washington Post* as "unraveling the twisted threads behind the Russian anti-Semitic forgery that has come to be known as *The Protocols of The Elders of Zion*," due out in 2005 from W. W. Norton. Eisner continues to lead by example, never once giving up his belief that comics can educate and enlighten the masses.

THE EARLY DAYS

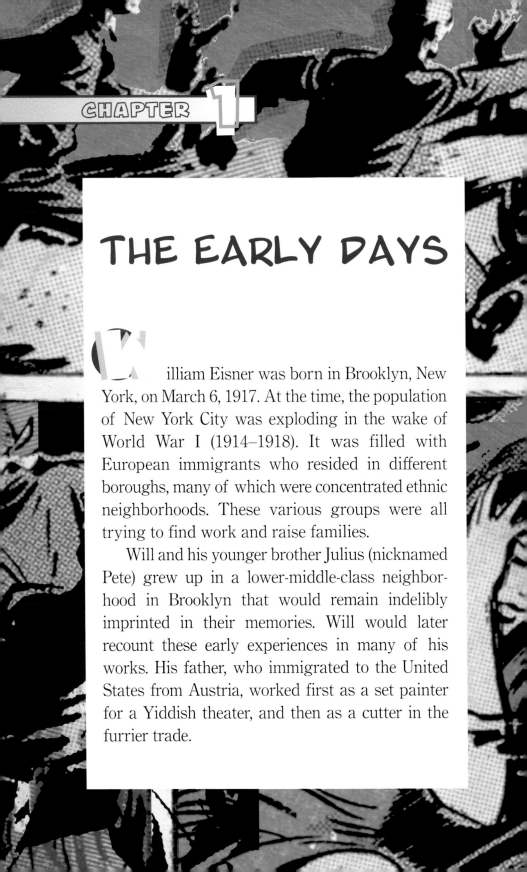

W illiam Eisner was born in Brooklyn, New York, on March 6, 1917. At the time, the population of New York City was exploding in the wake of World War I (1914–1918). It was filled with European immigrants who resided in different boroughs, many of which were concentrated ethnic neighborhoods. These various groups were all trying to find work and raise families.

Will and his younger brother Julius (nicknamed Pete) grew up in a lower-middle-class neighborhood in Brooklyn that would remain indelibly imprinted in their memories. Will would later recount these early experiences in many of his works. His father, who immigrated to the United States from Austria, worked first as a set painter for a Yiddish theater, and then as a cutter in the furrier trade.

Meeting expenses was difficult for the family as the country's economy staggered during the Great Depression of the 1930s. To help out, Will found a job selling newspapers. Every day he traveled from his family's

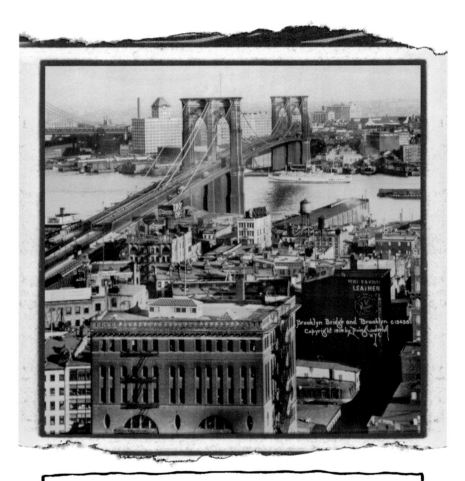

The city of Brooklyn and its famous bridge can be seen in this photograph from 1919, taken when Eisner was just two years of age. Growing up in Brooklyn and constantly being around its crowded streets, tenement apartments, and European immigrants inspired Eisner. New York later became the setting for many of his graphic novels.

apartment in Brooklyn into Manhattan. He had a little stand on Wall Street from which he sold newspapers and made almost four dollars a week. This was good money for the 1930s. But more important, working at the newspaper stand exposed Will to the plethora of comic strips in all the newspapers he sold. Back then, the city had nearly a dozen different daily publications.

During this period, the Eisner family relocated from Brooklyn to the Bronx, and Will enrolled in DeWitt Clinton High School, an all-boys' school with a rich history. It was also where he met Bob Kahn, a fellow aspiring cartoonist. During those years, the school was well-known for its attention to literacy and literature, providing a foundation in English skills that Will used throughout his career. While at DeWitt, Will drew and published his first cartoon, the *Forgotten Ghetto*, in the school newspaper. Soon after, he began contributing a regular comic strip, *Spunky*. He was also named art director of the school's literary magazine, the *Medallion*.

Art Student to Art Director

Eisner took after his father and displayed an aptitude for art as early as age eight. Seeing his son's artistic abilities, Will's father supported his interests while his mother tried constantly to dissuade him, fearing he would never have a successful career as an artist. She continually worried about her son's future. Eisner enrolled in the Art Students League of New York (an affordable art school where students of all ages draw from live nude models) in 1933. He studied under

renowned artists George Bridgeman and Robert Brachman. "For me," Eisner said in *Shop Talk*, a collection of conversations conducted between Eisner and his peers in 1980, "the Art Students League, for the brief time I attended, was one of my foundations. What I know about anatomy or drawing, I got there. I got a chance to study anatomy with George Bridgeman. I owe him whatever I know."

Eisner continued to sell whatever "spot" illustrations, small line drawings that usually accompany the text that appears in newspapers and magazines, he could while studying. But he was also interested in the printing process, so he landed an after-school job in a local print shop cleaning the presses for three dollars a week. Looking back, he later considered the job one of his most valuable because he learned about setting type from one of his coworkers, a heavy-set man who picked type out of a large rack and set it with a stick.

From there, Eisner was hired on staff at the *New York Journal American*, where he did a variety of tasks including drawing spot illustrations. He enjoyed his job at the newspaper, but really wanted to be concentrating on his own work. It wasn't long after that he left the journal to start a career as a freelance illustrator.

When *Eve* magazine hired Eisner as its first art director in 1934, he thought he had it made. Here he was, seventeen years old, and not only publishing his work but the work of others. His inexperience showed, though, as many of his cartoon choices did not fit the theme of the publication ("Dedicated to the modern American Jewess"), and he was soon fired.

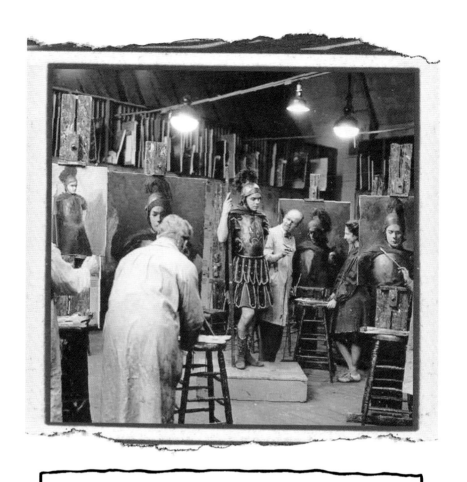

Art students in this studio are taking a drawing class in 1930 with artist George Picken. New Yorkers from all backgrounds were welcomed into the Art Students League where art instruction could be found for affordable rates. Eisner took many drawing classes at the Art Students League in the 1930s before taking his first professional job as an art director in 1934.

"Let me tell you the story," Eisner began during an interview with R. C. Harvey in the *Comics Journal*, "I was out of work [in the spring of 1936], and I ran into Bob Kane [his old schoolmate Bob Kahn who had since changed his name] on the street, and I said, 'What are you doing?' After high school, Bob started selling panel

cartoons. [At the time], it was a [lucrative] business. There was *Life* and *Liberty* and *College Humor* and a couple of other magazines like that. And he said, 'There's a magazine called *Wow, What a Magazine!* that I've been selling panel cartoons to, so you might go look for work there.'" Eisner took the advice only to discover that *Wow!* was being published by John Henle, whose experience was in shirt manufacturing, not magazine publishing. Because he had some extra space in his Fourth Avenue factory as well as investment capital, he decided to try his hand at publishing. Upon arrival, Eisner saw a man sitting at a desk, speaking rapidly into the phone. Eisner introduced himself to the speaker, but the man cut him off, saying, "I don't have time to talk to you now. I've got a serious problem here."

Undaunted and urged by his desire to work, Eisner insisted on showing off his artwork. The man, finally identified as Jerry Iger, asked Eisner to come back the following day, as he was getting ready to leave. Eisner refused to leave and instead accompanied the short dynamo of man. Beginning in the elevator and then up Fourth Avenue, Eisner walked, chatted, and showed his work. Iger, distracted, looked without comment.

Iger's problem was with the engraver, the place where the metal printing plates for publication were made. "In engraver's shops those days they had a big stone table in the center of the room where they would look at the metal plates as they came out of the acid bath," Eisner said. As he recalled, when they arrived at the shop, the engraver was having a problem with the metal plates cutting holes

in the mattes, which were like papier-mâché. Eisner, having experience in this field, spoke up and asked for a burnishing tool. He worked quickly and smoothly, softening the burrs that were found along the indentations on the plates and explaining where he learned the trick. The engravers, now impressed, asked Iger who the kid was. "He's my new production man," Iger said.

Samuel "Jerry" Iger, thirteen years Eisner's senior, was also a veteran of the *Journal American*, so a friendship between them began to blossom. Eisner went right to work at *Wow!* in July 1936, and not only did production work but his own features. His first was a two-fisted adventure called *Scott Dalton*. Eisner also took ideas from his high school days and refurbished them for *Wow!*. One was *Harry Karry* and the other was the *Flame*, an ambitious serialized project with a large cast of characters that was set in the past. Unfortunately, after two more issues, *Wow!* was canceled when poor sales forced Henle to withdraw his support.

Back on the street, Eisner hustled and found work with *Comic Magazines*, *Detective Picture Stories,* and *Western Picture Stories*. He also provided illustrations to the pulp magazines from Popular Publications and Street & Smith.

Eisner-Iger

Now in a panic about his thinning projects, Eisner was struck with a renewed inspiration. He called Iger, and

over lunch, pitched the idea that they go into business as comic-book packagers. Eisner imagined that comics publishers, which until then had been mainly reprinting comic strips, would eventually need new material. When they did, he and Iger could supply illustrated stories to any publisher. But Iger pleaded poverty, saying he had no money to invest in a new business. He was going through a second divorce and had no prospects. It was then that Eisner had an idea.

"I had $15 that I'd just gotten for a commercial job," Eisner continued in his interview with R. C. Harvey, "And I knew about a little building on Forty-first Street just off Madison Avenue that rented rooms, offices, for something like $5 or $10 a month [without a] lease. They usually rented them to bookies, little one-room things. So I told Jerry, 'I'll put up the dough. And I'll do all the art, and all you have to do is go out and sell it.' We made a deal, shook hands. We agreed to form a corporation—Eisner-Iger, my name first because I was the big money man."

At the time, Eisner was only nineteen years of age. Iger took a chance that he could handle the responsibility of starting a new business, but it was at times overwhelming. Eisner could draw well, but he was a lousy salesman who couldn't handle rejection.

A Brief History of the Comic Book

The graphic narrative has been a part of European and American culture for centuries. The lineage of what we

recognize as comic books today traces back to 1734 and William Hogarth's *A Harlot's Progress, A Rake's Progress*, and *Marriage a la Mode*.

Comics continued to evolve, largely on the pages of England's popular *Punch* magazine, launched in 1841. Germany, in 1865, published a precursor of the comic strip, *Max and Moritz*, which used sequential panels and balloons but was not quite in the familiar comic strip format we know today.

America got a taste of the graphic narrative with the publication of *Puck* magazine in 1877, followed four years later by *Judge*. The first newspaper comic strip, though, was 1893's the *Little Bears*, by James Swinnerton, which appeared in William Randolph Hearst's *San Francisco Examiner*.

The same year, the *New York Recorder* tried out color printing in its Sunday edition. A week later, Joseph Pulitzer used color in his *New York World*. In order to attract and retain readers for the Sunday edition, Pulitzer tried a new feature by Richard Felton Outcault. It was a riotous, large-panel illustration with many scenes. Standing in the middle was a young Irish boy wearing a garish yellow nightshirt; the Yellow Kid was born—America's first comic-strip star.

In rapid succession, other newspapers started running humorous and adventurous comic strips. These features became an indispensable attraction as several papers fought for the same readers in cities around America. Several of the characters went on to international fame, starting with Rudolph Dirks's *Katzenjammer Kids* and

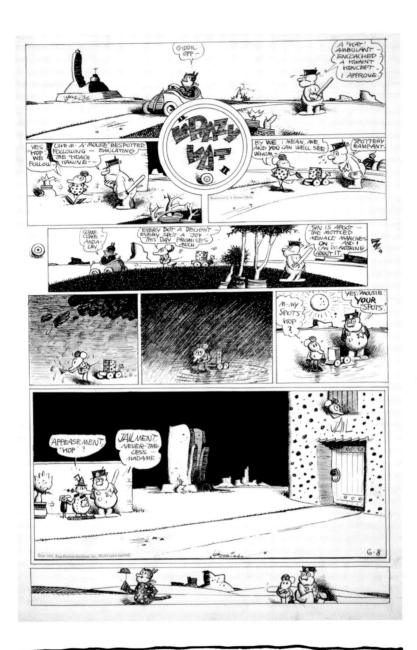

Artist George Herriman rendered these images of his character Krazy Kat, a daring cat perpetually in love with Ignatz, a mouse who constantly threw bricks at her. This panel of the syndicated comic strip is from June 1941. Herriman's cartoons, which Eisner read as a young adult, were a great influence on him. Krazy Kat debuted in 1913 and continued until Herriman's death in 1944.

Outcault's *Buster Brown*. But the first popular syndicated comic strip was Bud Fisher's *Mutt & Jeff*, which debuted in 1908.

Eastern Color Printing's sales manager Harry I. Wildenberg came upon the notion of taking the existing Sunday newspaper broadsheet and folding the pages into a smaller publication like a magazine. Wildenberg figured that Sunday comics reprints could then be used as an advertising premium (a giveaway to encourage shoppers). He was right. Gulf Oil was his first customer, giving away *Funnies on Parade*, printed by Eastern, with each gasoline purchase.

Further refinements led to the sixty-four-page comic book in just about the size it is today. Wildenberg and one of his salesmen, Maxwell Gaines, were successful in getting companies to buy these premiums. Shortly thereafter, Gaines put a ten-cent sticker on a stack of comics and left them on a newsstand. Sure enough, they sold well, and a new medium was born. *Famous Funnies* is credited with being the first comic book sold across America. Several other publishers immediately followed suit, all with reprints.

In 1935, *New Fun Comics* was the very first publication to feature all-new comics. A year later, Eisner approached Iger with the idea of providing a steady supply of material, anticipating a change in the business.

THE EISNER-IGER STUDIO

The Eisner-Iger Studio opened its doors in Manhattan in 1936. Quickly, the partners landed the Editors Press Service as their first major account, and Eisner provided comic strips, puzzles, and spot illustrations for its international clients.

Eisner-Iger wasn't the first such shop in comics; Harry A. Chesler was also in business in 1936. But Eisner-Iger is perhaps remembered best for the quality of its features and its reputation of talent.

Eisner was at first producing the comic material on his own, with Iger doing the sales and providing the lettering. The features included a revamp of the *Flame*, now called *Hawks of the Seas*. "I was enamored of Raphael Sabatini stories and N. C. Wyeth illustrations," Eisner told the *Comics Journal*. "Remember, we didn't have comic books in existence to build on in those days. Fellows today have

a whole history of comic books [with which to work], lots of examples. All I had were classical illustrators and the daily newspaper comics."

Hawks had now become a pirate feature, "full of the baroque angle shots that Eisner introduced to the business," according to cartoonist Jules Feiffer. Some say the look developed after Eisner began changing the comic strip to the comic-book format for American reproduction.

In 1986, artist Al Williamson helped see to it that *Hawks* was collected for modern readers. He provided Kitchen Sink Press with proofs from the then-defunct Editors Press, and in the introduction, Eisner wrote, "In retrospect, what is most significant to me about this is that its origin represents the confluence of my writing and art at that point in my career. As a youngster, my main source of literary [inspiration] was Robert Louis Stevenson and Raphael Sabatini. These, mixed with James Fenimore Cooper and later, the gritty pulp magazines, along with the short story genre extant at the time, formed the base of my sense of what adventure was all about."

As the studio grew during 1936, the five men believed to be working for it was actually Eisner using various pseudonyms. The studio needed more help as it grew, so it hired additional artists, including Bob Kane. Eisner finally had a chance to return his friend's favor of recommending him to *Wow!*.

Eisner would create a feature and then hand it off to others to execute. The first of these was *Sheena, Queen of the Jungle,* created by Eisner, but drawn initially by

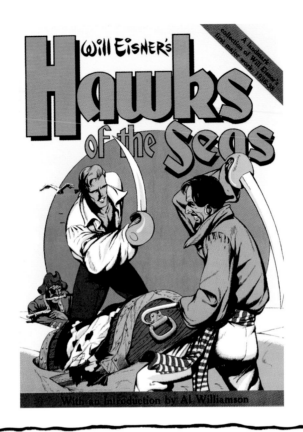

With an Introduction by Al Williamson

This cover, a reprint of *Hawks of the Seas*, represents Eisner's first professional work dating from the late 1930s. Inspired by adventure films of the era, *Hawks* was a comic that featured pirates as the stories' heroes. The reprinted version, published by Denis Kitchen's Kitchen Sink Press in 1986, was carefully photographed from the original proofs of the comics, given as a souvenir to Al Williamson who later became a well-known artist for EC.

Mort Meskin. *Hawks* and *Sheena* were among the more popular features distributed via Editors Press. Eisner was also producing strips called *Rex Dexter* and the *Three Brothers*.

As the popularity of comic books grew in America, the studio needed material from any source possible. Iger cannily sold the reprint rights for both

Hawks and *Sheena* to Fiction House, which used *Sheena* in *Jumbo Comics*, September 1938, and *Hawks* in November's *Feature Funnies*.

Learning the Biz

"Within a few months, the company was successful," Eisner told the *Jack Kirby Collector*. "It was growing very fast, and we moved to a larger office on Madison Avenue and Fortieth Street. But you see, in that office we pretended that we had five artists, but actually it was all me! I did five different stories with different names: Willis Rensie, W. Morgan Thomas, Spencer Steel, names like that."

Seeing how successful the syndication business was, Eisner and Iger decided there was still a niche to be filled. Eisner started the studio with Iger as a way to sell comic stories to a variety of sources. Most of these buyers were actually small East Coast newspapers that previously had no way of competing with the larger metropolitan papers, with bigger budgets to spend on original art. Eisner explained in the *Comics Journal:*

When King Features sold a strip to, say, the *Newark Star Ledger*, the *Star Ledger* had regional rights, so none of the papers in that "region"— those in all the small towns surrounding Newark with little newspapers—could get any of the strips the *Star Ledger* was publishing. I said, "Let's see what we can do about that." And Iger said he'd go with that. So we hired two

salesmen, two hotshot salesmen—Riley and Begg. I don't remember their first names, but they were fast-talking hotshots. The idea was that they would go into these small-town newspapers and sell them a page of our comic strips. The last panel of each strip was blank. They'd say they would go out and sell those blanks as advertising space. The advertising income would pay for the comic strips, so the paper would get a page of comic strips for nothing. But what the newspaper guy didn't realize is that these two hotshots would be leaving town the week after they'd sold a week's space, say, to the corner drugstore, so the next week, the newspaper guy would have to go back to the corner drugstore and sell the space again. At first, he didn't realize he'd bitten off a little more than he could chew. That was Universal Phoenix Syndicate."

Eisner also contributed *Muss 'em Up Donovan,* a feature created and drawn by Eisner for the syndicate, that reprinted first in 1937 in Comic Magazine Company's *Detective Picture Stories* and then a year later in Centaur's *Funny Pages.* Fellow artist Jules Feiffer said in his influential the *Great Comic Book Heroes,* "Will Eisner was an early master of the German expressionist approach in comic books—the Fritz Lang school. *Muss 'em Up* was full of dark shadows, creepy angle shots, graphic close-ups of violence and terror. Eisner's world seemed more real than the world of other comic book men because it looked that much more like a movie."

A Call for Superheroes

In late 1938, publishers were reeling from the arrival of Superman in DC Comics and *Action Comics*, and suddenly there was an appetite for costumed heroes with amazing abilities. DC's accountant, Victor S. Fox, saw the possibilities and left to form his own company, Fox Publications (in the same office building!). His first action was to order a knock-off from the studio.

Wonder Comics, featuring Wonder Man, was Fox's first publication. It appeared in May 1939, and that same month, DC debuted *Batman* in *Detective Comics*'s issue 27 by writer Bill Finger and artist Bob Kane.

DC immediately sued Fox, who canceled Wonder Man comics after one issue, and the case went to trial in 1940. "You know, the reason we left Fox was that Superman lawsuit," Eisner said in *Shop Talk*. "Actually, I refused to lie on the witness stand for Fox. So I told the truth: that he—Fox—set out to imitate Superman. His defense disappeared. It's all in the records. As a result, Fox refused to pay Eisner & Iger about $3,000 he owed us, an absolute fortune at the time." The court found in favor of DC, but by then Fox had established his line of titles, largely fueled in those early days by the Eisner-Iger Studio.

However, Eisner-Iger had found a more reputable client in Everett "Busy" Arnold, who, in 1939, contracted the studio to provide features for his new Quality Comics Group. Eisner got right to work, generating a huge number of characters, most of which populated Quality's titles for years to come. The first such book was *Feature*

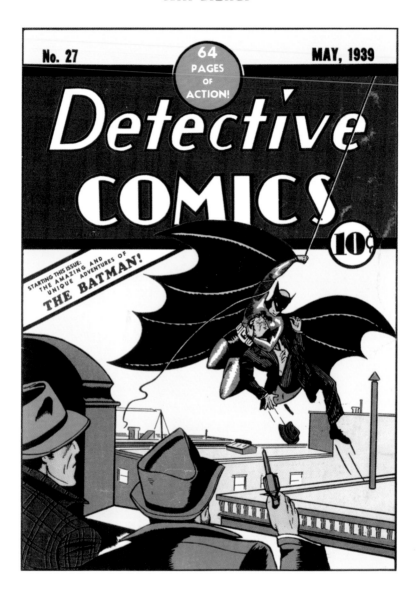

The 1930s were a renaissance period for comic books that featured superheroes of all types and abilities. This issue of DC's *Detective Comics* number 27 is one of the most sought after by collectors of the medium. It features the debut of the legendary character Batman, created by artist Bob Kane and written by Bill Finger.

Comics number 27, dated December 1939, and starring the diminutive hero Doll Man.

By then, the studio was growing and it continued to hire additional artists, relocating to Madison Avenue and Fifty-third Street. Eisner recounted one humorous incident to the *Jack Kirby Collector* involving Kirby, later considered the king of comic-book artists:

> When we moved to a new office in a nice building, we had a towel service for the artists to wash their hands, and we would buy a towel for each of the artists so they could wash up. The people who supplied the towels, however, were mafia! They were charging more and more money, so my partner Iger said, "Look, let's find another towel service [that's] cheaper," because at that time we had ten to fifteen artists and it was beginning to cost money. So I called them and said, "Look, we would like to find another towel service." So I get a visit from their salesman. He had a white tie, a black hat, a broken nose, y'know? Scarface! And he came in and said, "Are you really not happy with the service?" I said, "Well, we want to find another . . ." He said, "There is nobody else that can service this building."

The thug and Eisner started to raise their voices, and they were interrupted when the door to the artists' room opened and out rushed Kirby. The two-fisted tough guy from Brooklyn stood up for Eisner, refusing to back down in front of the mobster. Eisner, afraid his top artist would be injured, tried to coax Kirby to calm

down. Kirby would have none of it and cowed the thug into leaving. He finished by saying, "If he comes to see you again, call me and I'll beat him up!"

In time, the studio employed people who would go on to respected careers in the comics field, including Kirby, Lou Fine, Bob Kane, Dick Briefer, Chuck Mazoujian, Mort Meskin, Bob Powell, George Tuska, Klaus Nordling, Nick Viscardi, and staff writer Audrey "Toni" Blum, daughter of studio artist Alex Blum.

By then, Eisner had perfected a system whereby he'd help create a character and either write the first stories or describe them to Audrey Blum or Dick French. Eisner was the man behind the concepts and the characters. He would design the characters, then the artist taking over the strip would copy his design. Eisner would use a non-photo blue pencil (a pencil that won't reproduce marks that would show up on the final prints) on sheets of illustration board and quickly rough in where figures and word balloons should go. The writer would then add the dialogue, which would be lettered onto the boards, followed by artists who would go in and finish the pages, first in pencil and then in ink.

The Studio

The office/studio was set up to resemble a classroom, with drawing tables and taborets, which are freestanding artists' drawers that hold supplies. Ideally, Eisner, who had his desk up front like the teacher, had the pencillers facing him against the right-hand wall. Most

artists were expected to pencil and ink their own work, but with time, younger artists were brought in to provide background art help as well as to clean the pages as necessary to prepare them for reproduction by the client.

At first, Eisner found talent by advertising in the local newspapers, interviewing the long line of candidates on Monday mornings and then putting the selected few immediately to work. Over time, though, the artists started to talk to their peers, members of the growing number of Manhattan studios. As a result, a fair amount of raiding and recruiting was going on by the early 1940s. Eisner was filled with a mixture of pride and frustration at the turnover, recognizing he must be doing something right for his artists to be wanted elsewhere.

Rather than pay the talent a page rate, as established by the publishers, Eisner wanted to instill in them a sense of pride in the studio and put everyone on a salary. Iger thought Eisner was crazy; the older partner thought artists would take advantage of the salary system and produce fewer pages than necessary. He was quickly proven wrong and stopped his criticism.

Eisner, now at about age twenty, was supervising every page, asking for corrections, and working directly with artists to improve their work. He'd walk up and down the aisles, watching his people at work with his hands folded behind him. Along the way, he also absorbed lessons from his people and eventually his artistic style matured.

In time, Eisner gave his proven talent more freedom to generate continuing story ideas for the

EISNER'S PEERS

Eisner surrounded himself with the best writers and artists he could find. At its height, the Eisner-Iger Studio was producing enough material for fifteen sixty-four-page comics every month. "I was running a shop in which we made comic-book features pretty much the way Ford made cars. I would write and design the characters, somebody else would pencil them in, somebody else would ink, [and] somebody else would letter. We made $1.50 per page net profit. I got very rich before I was twenty-two," he told historian Jim Steranko in the *History of Comics*.

Many of these artists later gained fame for their contributions to the medium. The best known of the studio graduates was Jacob Kurtzberg, later known as Jack Kirby. Kirby, partnered with Joe Simon, went on to fame as cocreator of Captain America and kids' gang comics such as the *Boy Commandos*. They later invented the romance comic genre, and in 1961, Kirby teamed with writer Stan Lee to cocreate the Marvel universe of superheroes, starting with the Fantastic Four.

Perhaps the best artist in the studio was Lou Fine, a man Eisner remains fascinated by even today. He was heavily influenced by the superior artists of the early twentieth century, bringing that influence to the studio in the late 1930s. Before joining him on Eisner's most famous cartoon series, *The Spirit*, Fine was the go-to artist for new features such as *Doll Man*, *Uncle Sam*, and the *Ray*.

Reed Crandall was a superb artist, a master of line drawing, who made his mark first on Blackhawk, a character who was popular enough to headline *Military Comics* and his own title. Crandall later finished his career producing exquisite stories for Warren Publishing's *Creepy and Eerie*.

Nicholas Viscardi, later known to fans as Nick Cardy, worked on many of Busy Arnold's Quality titles before moving to DC and is best known today for his 1960s work on the *Teen Titans, Aquaman,* and *Bat Lash*.

George Tuska got his start in the studio and was later one of the most revered crime-fiction artists before turning to superheroes in the 1960s. A very young Joe Kubert also got his start with the studio, erasing pages and cleaning up while he soaked up whatever lessons he could. Kubert went on to a stellar career as writer, artist, and editor, best known for *Sgt. Rock* and the graphic novel *Yossel*, which was published in 2003.

established features. Toni Blum, with whom Eisner had a brief romance before she married studio mate Bill Bossert, proved proficient enough that she created stories without Eisner's input. Bob Powell, one of Eisner's best artists, preferred creating his own stories, and after proving himself, Eisner allowed him to take a certain amount of ownership of his assigned characters.

To Eisner, the artist was the principal storyteller, taking the writer's idea and adjusting it for maximum visual impact in a given number of pages. Although

Eisner or Blum and others wrote a synopsis, the artists were given free reign to adjust the plot as they deemed appropriate. On every story Eisner personally wrote for others, though, he provided rough page layouts since he had the experience to get his ideas across visually.

While successful with the studio, there was a melancholy aspect to it for Eisner. "There was something of a social life [within the studio setting]," he told the *Comics Journal*. "But one of the problems I had was that I was about the same age [or younger than] these guys; and it was a little difficult for me to be part of their social activity. When they'd go out and have a beer at the end of the day, they never invited me along. I learned to keep in my place, so to speak."

He also had come to recognize how comics could be useful beyond mere entertainment.

"I went to Kingsport Press to get them to bind up a book, and I called it *Education Comics*," he recalled in *Shop Talk*. "Then I tried to sell it as comics in schoolbook form. I couldn't sell it. Later, after I left Eisner & Iger, Jerry sold the idea to [Al] Kanter, who then made it *Classic Comics*, in comic-book format, later *Classics Illustrated*. Before that, we were selling them as features overseas. The idea itself, of illustrating classic stories, was very acceptable overseas. We sold to Canada and through Editors Press to Europe. But here in the states, until that point, it never really caught on."

THE SPIRIT

In 1940, Eisner received a call that would change his life. Everett "Busy" Arnold telephoned and invited Eisner to lunch, a scene he later described in his introduction to *The Spirit Archives* volume 1.

What Arnold had in mind was completely different from what Eisner-Iger was producing. The conversation over lunch, which included a man named Henry Martin, was a proposal to Eisner to create a comic drawn entirely by himself. Arnold and Martin proposed to Eisner that he write and draw a sixteen-page comic magazine that would be nationally syndicated and inserted in Sunday editions of major newspapers. This was something that had never been done before.

Martin was a sales manager of the Register & Tribune Syndicate, which had become increasingly concerned about their client newspapers over the comic-book competition for their younger readers.

Their offer was simple: Eisner would create, write, design, and produce their supplement. But when he was offered a syndicate contract to do the work, Eisner refused to sign it. He instead negotiated a partnership agreement that would enable him to retain ownership over his original characters. As a compromise, the copyright would remain in Arnold's name, but when the relationship between them terminated, the property and the ownership of all rights would return to Eisner. Even at a young age, Eisner knew that he should control his own work. He was wise enough to negotiate a better deal for himself and his future as an artist. As he recalled in *The Spirit Archives*, "I thought at the time that my strength in these negotiations stemmed from their respect for my artistic and creative ability, later I found out that it was really my reputation as a reliable producer that was more important to them. A newspaper feature had to be delivered on time without fail."

Time to Choose

Eisner was faced with a predicament: he had to choose between Eisner-Iger, a company he started himself that was both commercially successful and profitable, or go out on a limb and produce and design his own comic. Eisner-Iger had a full staff of artists and the company was now creating comic-book stories for various publishers. To make matters worse, there was a war coming on and Eisner would probably be drafted. While he was flattered by the offer to produce his very own comic book, the syndicate business was speculative, as risky as the possible fate of any new comic feature. The new venture

was a gamble at best. Even Eisner's partner, Jerry Iger, who stood to acquire Eisner's half of the company, cautioned Eisner of the risk.

But it was the opportunity of a lifetime for Eisner. It was his very first chance to fully explore the comic medium. By 1939, he was completely convinced that comics had true literary potential. He had decided to spend his life exploring the possibilities of tapping into whatever his imagination would allow. At the time, Eisner believed he was trapped into producing the same material again and again. He felt as though the comics he and the other artists were producing at Eisner-Iger Studio were formulaic adventure stories for the same readers. If he took the chance and syndicated a national comic, it would give him a chance to reach an adult audience. Eisner would finally have a chance to write and draw more sophisticated material.

Eisner was ambitious. He decided to take the chance to realize his dream of expanding this medium beyond its existing parameters. He was certain that comic drawings were capable of more varied content that had not before been attempted. Furthermore, this deal he negotiated allowed him enormous creative freedom. Finally, he decided that doing the new comic book was worth the gamble. He sold his shares of Eisner-Iger to Iger and went to work.

New Digs

As part of the separation, Eisner got to pick a handful of artists to come work with him in a new studio. Out of

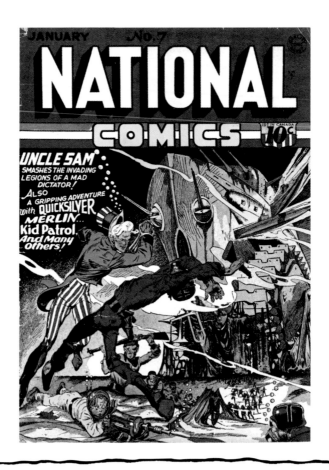

This cover of *National Comics* likely inked by Lou Fine, is from January 1941. *National Comics* was among the clients that Eisner had after he established his new Bronx studio in 1940. Eisner made the switch to start another studio after Everett "Busy" Arnold gave him the opportunity to create his own nationally syndicated comic strip, *The Spirit* (1940–1952), as a full-color, sixteen-page Sunday supplement. Each *Spirit* contained three stories, meant to appeal to adults.

the fifteen people working at Eisner-Iger, he picked Fine, Viscardi, Powell, and Cuidera and set up offices in Tudor City, in the Bronx, beginning in January 1940. It was a two-room apartment, with the bedroom acting as Eisner's office and the main room as a studio.

Eisner created three features, keeping the lead for himself and doling out the other two, while negotiating with Arnold for his new studio to also provide work to two other Quality Comics titles, *National Comics* and *Hit Comics*.

"The *Spirit* story was seven pages for the first thirty-two weeks (his real name would be Denny Colt), the costumed girl (Lady Luck) [was] four pages, and the magician (Mr. Mystic) [was] five pages. The design for those was easy and quickly agreed upon," Eisner wrote in his introduction to *The Spirit Archives* volume 1. Dick French and Chuck Mazoujian agreed to do Lady Luck, actually socialite Brenda Banks who wore an all-green outfit to fight crime. Bob Powell would work on Mr. Mystic. As before, after Eisner created Mr. Mystic, Powell took possession of the feature, writing and drawing it, making it his own. Mystic was named Ken (only once), a variation on the "Yarko the Great" feature Eisner conceived for overseas markets (and which Victor Fox used to replace Wonder Man in *Wonder Comics* number 2). A survivor of an airplane crash who is found by Tibetan monks, he is trained in the mystic arts before returning to the United States.

There was one moment of tension later, when Powell announced he wanted to leave, having received a better offer from Arnold himself. Eisner was annoyed, considering he was in partnership with Arnold to produce the Sunday section. After an argument, Arnold withdrew the offer, leaving a very angry Powell to remain at the studio.

In keeping with his approach to character creation, the three features were varied enough to give the reader choices. To Eisner, here was a chance to avoid some of the comic-book stereotypes that had already cemented themselves, such as heroes who wore costumes and displayed daring feats. Instead, his lead, Denny Colt, was going to be closer to the adventure strip heroes such as Milton Caniff's Pat Ryan from *Terry and the Pirates*.

He was hard at work on the first feature, getting a feel for the city and its characters, when he received a call from Arnold, who was concerned about the nearing deadline. Arnold was calling from a local bar, and he

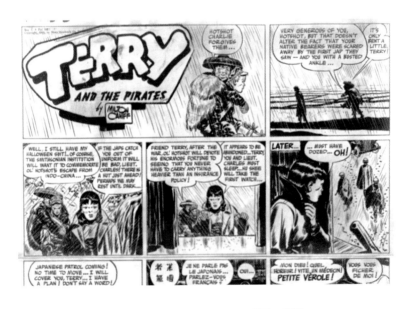

The character Pat Ryan, who debuted in artist Milton Arthur Caniff's strip *Terry & the Pirates* (1934–1946), was not only a departure from the myriad of superhero characters that were popular at the time, but an inspiration for Eisner's Denny Colt (the Spirit) character that debuted in 1940. This page of *Pirates* is from 1945.

asked Eisner how things were coming along. Arnold wanted to know which character Eisner decided to focus on as the lead. As the two chatted, Eisner kept drawing. He described the hero as stalwart, clean-cut, intelligent, and athletic, but Arnold only wanted to know if he wore a costume.

Apparently, Arnold was convinced that he could only sell a comic-book hero if the hero was costumed in some way. It was what readers expected. Eisner stalled for a moment, and then quickly drew a mask on his character. He happily reported to Arnold on the other end of the telephone line that his character wore a mask, gloves, and a blue suit. (In actuality, however, Eisner tried to postpone the costume requirement for as long as he could. The Spirit actually had no mask until the second week, June 9, 1940.) As expected, Arnold responded with enthusiasm.

The Spirit Debuts

Eisner wrote and drew, supervised his colleagues, and got his studio established. Then, on June 2, 1940, five Sunday newspapers around the country delivered the first *Comic Book Weekly* to readers. At first, people were unsure of this comic book-sized item in their paper, and it took time for it to catch on. But it was well received enough that imitators quickly announced their own plans including one from King Features starring Red Barry. Fox himself planned another one to spotlight Blue Beetle, who was already in comic-book and comic-strip form.

"The comic strip, [Eisner] explains, is no longer a comic strip but, in reality, an illustrated novel," Norman

Abbott described in the *Philadelphia Record*'s feature story, introducing the daily version of *The Spirit*. "It is new and raw in form just now, but material for limitless intelligent development. And eventually and inevitably it will be a legitimate medium, for the best of writers and artists." It took Eisner until 1978 to bring these embryonic ideas to life, which shows he truly believed in the medium's potential from the beginning.

Later, comic historians like artist Jim Steranko described Eisner's early work as visionary, although it still had some obvious—but minor—shortcomings. The early *Spirit* drawings were just a hint of what was to follow in Eisner's long and prolific career. Although he sometimes lacked experience, as noted in areas where his perspective or anatomy was off, or where his drawings were inconsistent from panel to panel, the work was actually like a diamond in the rough. Eisner was precise, and he made clear decisions about his work. He knew where he had to take his characters, and he pushed them to get there.

According to the *Will Eisner Reader*, in the original feature, a detective named Denny Colt is put into suspended animation by the evil Dr. Cobra. After Colt is declared dead, he sets up shop as a masked crime fighter in his tomb in Wildwood Cemetery and adopts the name "The Spirit." Commissioner Dolan of the New York City police appears in the first story. In the second section, published on June 9, 1940, Ellen Dolan, the commissioner's daughter and the woman who will win the Spirit's affections, makes her debut. Ebony White, an African American sidekick, also appears in the second issue. Ebony became a controversial character because

THE ORIGIN OF THE SPIRIT

June 2, 1940

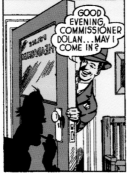

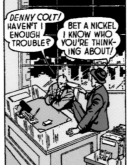

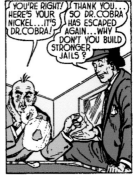

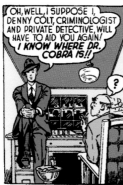

This "splash" page of *The Spirit* first appeared in 1940. Today, Eisner is considered one of the comic industry's most accomplished contributors. His full-color splash pages, often a unique form of visual foreshadowing for the comic story that was to follow it, are now revered for their modern, expressionistic qualities.

he was written as a stereotypical black youth, which was common in the days after World War II, but which seemed inappropriate to contemporary readers.

Denny Colt was drawn as a middle-class crime fighter because Eisner wanted to emphasize his humanity, making readers empathize with his problems. The stories were self-contained, but over time, a supporting cast of characters also appeared. "Just as Milton Caniff's characters were identifiable by their perennial WASPish, upper middle-class look, so were Eisner's identifiable by that look of just having got off the boat. The Spirit reeked of lower middle-class: his nose may have turned up, but we all knew he was Jewish," wrote Jules Feiffer in *Great Comic Book Heroes*.

The July 7, 1940, installment showed the beginning of an element that Eisner would become known for: the distinctive "splash" page. Eisner's splash page was a full-color single illustration that enticed readers to complete the story that followed. After that, the opening page of the Sunday section became a visual delight.

Eisner later explained his innovations such as the splash page as merely creative problem solving. In fact, he is often quoted as saying that his creative strides were nothing more than meeting or exceeding the demand of a new format, or just looking at something in a new and challenging way. For Eisner, even creating *The Spirit* was an attempt to solve a problem. At the time, newspapers were very concerned about losing their youth market. In order to keep pace with the younger readers who were being driven away toward independent comic books, they had to tap into what the comic medium had to offer

as a newspaper supplement. Creating *The Spirit* gave Eisner the chance to do something he had always wanted to try: creating an innovative comic for a varied audience. The so-called splash page, which Eisner is credited with innovating, was a result of the fact that *The Spirit* was a freestanding supplement in the newspaper, very much like the television program guides or advertisement booklets in newspapers today. Eisner created the splash page to get readers' attention. Also, because he now had only eight pages to tell the Spirit's story—and later just seven—he had to set the scene immediately and did so on the cover splash page.

A Variety of Characters

Eisner knew something about living in the ghetto, and he always set stories there whenever possible. He certainly couldn't do it with the heroes created for Quality's titles, but for *The Spirit* and his more recent original works, he rarely strayed from the tenements. In doing so, he populated them with characters obvious to those environments. In Central City, the renamed Manhattan that was the Spirit's base, he would work with police commissioner Eustace P. Dolan. Once the Spirit was on the case, though, he would encounter street people, wage earners, shoeshine boys, newsstand operators, peddlers, grifters, and all kinds of streetwise inhabitants.

To his credit, Eisner also saw to it the streets were filled with people of color. In a time when African Americans were cast as little more than domestic help in feature films, the Spirit was often accompanied by an

EISNER'S CREATIONS

Will Eisner is best known today for creating *The Spirit* for Sunday newspapers, but he was also a virtual one-man idea machine for the Eisner-Iger Studio. When Everett "Busy" Arnold asked for a new cast for his Quality Comics line, Eisner created a set of enduring and varied characters.

Many of these crime fighters were conceived by Eisner, who either wrote the first few installments for them, or described the actions they were involved in for other artists to draw. He drew few of the actual stories, just handling rough layouts and letting his peers produce the actual artwork.

Jules Feiffer noted in *Great Comic Book Heroes*, "[Eisner's] stories carried the same weight as his line, involving a reading, setting the terms, making the most unlikely of plot twists credible."

The first such creation was Doll Man, who could shrink to six inches and fight crime in a circus aerialist's outfit. The first in a series of Eisner characters debuted in *Feature Comics* number 27, in 1939, and was drawn by Lou Fine.

In May 1940, *Crack Comics* debuted with Eisner's the *Black Condor*, featuring a visually striking hero, again drawn by Fine. The Black Condor—having one of the sillier origins—was raised by condors and then grew to look astonishingly like a dead senator who he then passes himself off as, unbeknownst to the politician's fiancée.

Perhaps his best-known Quality hero is Blackhawk, the Polish freedom fighter who led an international squadron of pilots who opposed the Axis threat from

Germany, Italy, and Japan. The feature from *Military Comics* number 1 was so popular, he gained his own title that lasted until 1968 and was immortalized in a 1953 movie serial featuring Kirk Alyn. The comic was initially drawn by Chuck Cuidera and was subsequently joined by the famed stylist Reed Crandall.

With patriotism running at an all-time high due to World War II, it made sense for Eisner to bring the spirit of America to life. In 1941, Uncle Sam headlined his own quarterly title. Again, Fine lent his considerable talent to the stories. After Quality Comics folded in the 1950s, DC Comics purchased Eisner's characters and continues to use many of them today.

African American youth named Ebony White. While drawn in a somewhat stereotypical style, Ebony remained a faithful friend to the Spirit and was treated fairly by other white members of the cast.

Years later, Eisner remarked that he took great care to create a varied cast of characters. At the time, in the 1940s, most blacks in entertainment were still portrayed in stereotypical ways, such as in the popular *Amos & Andy* in which blacks were played by white men on a long-running radio program. Although that sort of racist humor was commonplace, Eisner chose a different, more progressive path for his characters. Later, he remembered getting a lot of support from readers who appreciated his refreshing approach. In fact, Eisner was the first comic

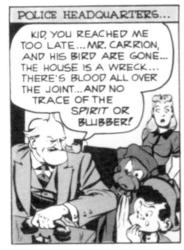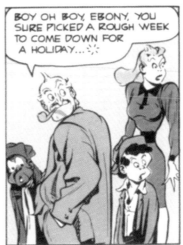

Before long, Eisner became known for his variety of *Spirit* characters, some of which are shown in these panels from April 21, 1946. Ellen Dolan was the love interest for crime-fighter Denny Colt, whose African American apprentice was named Ebony. The Spirit's nemesis, the *Octopus*, the police commissioner of Central City, Eustace P. Dolan, and the female spy, *Sand Serif*, also made frequent appearances in the series.

artist to depict an African American police detective, Detective Grey, who did not speak with a minstrel dialect, which was an offensive stereotype. Although Eisner never offered himself as an early advocate for civil rights, nor did he believe himself part of the later civil rights movement, drawing his characters—all of his characters—as strong and intelligent people were the standards he set for himself.

Eisner also introduced Dolan's daughter Ellen in the second installment. She was the blonde love interest, always pining for the Spirit, but never managing to capture his heart. Over the following years, Eisner went on to create a variety of tough, capable female foils for his protagonist, no doubt inspired by the strong women

seen in the movies of the day. While Dolan was the father figure to the Spirit, Ellen was the pure, chaste, ideal woman for him.

On the other hand, his first femme fatale, Silk Satin, who was introduced on March 16, 1941, proved far more interesting. She was a reformed criminal who went on to perform espionage for the British intelligence service during World War II (1939–1945). As a result, she and the Spirit repeatedly crossed paths. Each time, sexual tension was present, but neither acted on it.

Breaking New Ground

By December 1940, all the distinctive Eisner storytelling ingredients were apparent, and his well-known *Spirit* stories had gained a significant readership. Eisner was organically advancing the art of cartooning with each passing week, introducing some new plot twist or detail that proved that the medium was capable of much more than earlier artists had thought possible.

The Spirit was starting to acquire fans. Readers were surprised when they found themselves addicted to this comic fantasy world with serialized characters and recurring plots. It was a comic strip, but it was also inventive, unexpected, lively, realistic, and sometimes even grim. The tales of *The Spirit* took readers from a story like "Ten Minutes" that detailed temptation and punishment in the ludicrous but fascinating story of a talking cockroach that dies a hero's death, to a prisoner being shaved for execution while sharing his last conversation in "The Barber," to "The Awful Book," which

tells the story of how a loathsome critic falls victim to his own imagination. While the standard comic books of the period used the same formula over and over, *The Spirit* constantly broke new ground.

Just over a year later, on October 13, 1941, the syndicate launched a daily version of the strip. As was the custom of the day, its plot was separate from that of the Sunday chapter. Eisner, who knew how to tell stories ranging from one to twelve pages, now had a new format to master: editors around the country were expecting the daily serial to last anywhere from six to ten weeks. Any longer and the story was undesirable, and shorter, its creation would have been creatively impossible.

Fortunately, the New York area was filled with writers and artists who were willing to offer Eisner their advice. He chatted with his peers and figured out how to master the unique requirements of telling a story in four panels a day. That fourth panel, he learned, had to be enough of a cliffhanger to make people want to read the following day's installment. On Friday, there had to be a bigger cliffhanger to keep people interested over the weekend. Monday had to recap the action, solve the cliffhanger, and move the story forward. The Saturday installment couldn't advance the story too much since it had the lowest circulation of the week and no one wanted a confused reader. The strip ran daily until March 11, 1944, not an unrespectable amount of time, but certainly not a hugely successful run.

MR. EISNER GOES TO WAR

On the wake of the December 7, 1941, attack on the U.S. naval base at Pearl Harbor, Hawaii, the United States entered World War II and thousands of young men volunteered. But because America needed even more soldiers, a draft was imposed. Eisner was at his desk that fateful Sunday, eating lunch, when word of the attack was broadcast on the radio. By then, *The Spirit* was considered a success, nearing the end of its second year, with a daily segment already in print.

Arnold, not one to miss a trick, began reprinting the stories, one per issue, in *Police Comics*, which was headlined by its most successful non-Eisner-created character, Jack Cole's Plastic Man.

Eisner, anticipating his eventual draft, had shifted into overdrive, stockpiling as much material

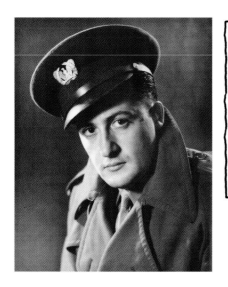

This image of Eisner was taken while he was enlisted in the United States Army during the 1940s. Eisner continued drawing while he was away from New York, at first publishing a strip called *Private Dogtag* for the *Flaming Bomb*, his camp's newspaper. Eventually, the same character became better known as Joe Dope.

as possible so as not to leave Arnold and the syndicate in a jam. He also wanted to make sure the studio was running as efficiently as possible so it could continue while he was gone.

Once called to duty, Eisner reported in May 1942 and received training at New Jersey's Fort Dix before being assigned in the Ordnance Department at Maryland's Aberdeen Proving Ground. Being an artist, he did manage to contribute the feature *Private Dogtag* (a reworking of the Titmouse O'Toole character he introduced in one *Spirit* section mixed with a healthy dollop of Elzie Segar's *Popeye*) and gag cartoons under the heading *Bunk Fatigue* to the camp newspaper, the *Flaming Bomb*. At first, he managed to find the time to write *Spirit* scripts on sheets of yellow paper and send them by mail to Tudor City in the Bronx.

Big Shoes to Fill

When it came time for others to write his character, the first to do so was science fiction and part-time comics writer Manly Wade Wellman, who had been hired by Arnold. In addition to his experience writing pulp fiction, he had also written adventures featuring Fawcett's Captain Marvel and Spy Smasher plus Quality's Plastic Man and Blackhawk.

William Woolfolk, a talented and prolific writer whose career spanned from pulps to television, quickly followed in Eisner's footsteps. Arnold hired him, too, after Woolfolk proved himself on a variety of Quality characters.

The new stories being told did not vary much from the themes Eisner had established before he was drafted. Central City remained the hub of activity, and all the recurring characters could be counted on to make appearances, including Silk Satin, now a British spy since, after all, there was a war going on. It should be noted that no major characters introduced during Eisner's time away remained with the feature upon his return. This was Eisner's baby, and no one was going to tinker with it.

Lou Fine

Drawing the majority of the wartime adventures was Lou Fine, considered by many to be among the greatest artists the comics industry had ever seen. Fine and Eisner didn't

always get along, but Eisner had tremendous respect for Fine. Fine, in turn, had a professional approach to his comic-book work, never abandoning it for commercial projects, however lucrative. Fine debuted his own newspaper strips, "Adam Ames" and "Peter Scratch," in the 1960s before his premature death in 1971.

Fine was an early Eisner-Iger Studio employee, and the first time he replaced Eisner directly was on the *Flame*. He came over to join Eisner shortly after the split from Iger. Over time, Eisner respected Fine enough to provide him with his own room in which to draw. Early on, Fine assisted Eisner in producing *The Spirit* artwork, and when the daily feature was launched, Fine handled the art on his own.

His Spirit character resembled Eisner's, but had a smoother line. In addition, try as he might, Fine never managed to draw the character's hat exactly as Eisner had. Still, when Eisner stopped providing the Sunday art, Fine moved from the daily feature to the weekly one. Plastic Man's Jack Cole stepped in to handle the daily from May 18 to August 8, 1942.

Arnold was so concerned about losing Eisner during the war that right after the Pearl Harbor attack, he asked Cole to create a *Spirit* knockoff, one Arnold could own outright. Cole agreed and helped create a virtual duplicate called *Midnight*, which debuted in *Smash Comics* number 18. It matched the tone of the weekly feature for the first year or so, and eventually, Cole's penchant for sight gags worked their way into the strip, lightening it up considerably. The timing leads historians to believe

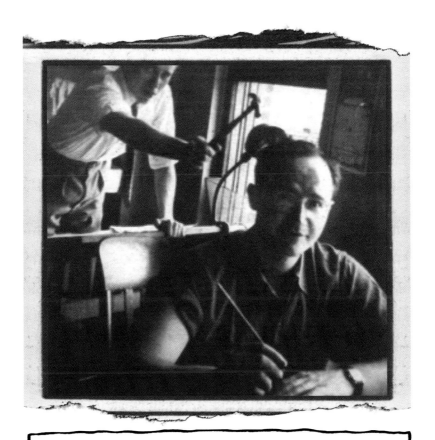

Seen in this early photograph is Louis Kenneth Fine, among the most talented artists who worked in the Eisner-Iger Studio in the 1930s and 1940s. Fine was especially gifted when it came to producing cover art. He worked on various comic series, including *Wilton of the West*, the *Count of Monte Cristo*, the *Flame*, *Jumbo*, *Sheena*, and *The Spirit*.

that it was in the spring when Eisner took Cole to dinner. When Eisner asked him to help on the daily feature, the subject must have come up of adding humor to *Midnight* in order to differentiate it from *The Spirit*.

Fine preferred to only pencil the Sunday feature and had inkers finish the artwork, among them John Belfi and Alex Kotzky, who went on later to create the popular the *Girls in Apartment 3-G* comic strip. Sam Rosen would do the lettering during this time.

"So while the style changed, there was an honest effort to retain the essence of what I had created. Gradually I became more comfortable with the stories and art. I would from time to time try to urge Lou Fine to 'loosen up.' He had trouble with fitting the Spirit's fedora on his head and I sent him a sketch showing how I thought it should be done. I had to learn to keep from meddling; after all, he was minding the strip for me until I returned," Eisner wrote in his introduction to *The Spirit Archives* volume 6.

Michael T. Gilbert, a respected comics artist and historian, offered his analysis of Fine's art in an introduction to *The Spirit Archives* volume 11: "Fine was primarily an illustrator, while Eisner was a storyteller. Fine could tell a story well enough, but often sacrificed clarity and flow for a more impressive picture. Eisner was no slouch in the art department either, but clear storytelling was his main concern. A brilliant writer as well as artist, Eisner knew the value of a good story. These differences were manageable early on, but became more of a problem over time."

When Fine began his career as a comic artist during the Great Depression, he quickly became known for his dramatic covers and gripping superhero stories. His drawing talents allowed him to exaggerate the proportions of the human figure beyond reality, which helped convince readers that his unusual stories were plausible. Fine's illustrations, which were inspired by classic illustrators like Heinrich Kley, Royal Cornwall, and J. C. Leyendecker, were beautifully drawn, with exquisite lines and intelligent compositions.

Fine's abilities were perfect for *The Spirit*, and he did a remarkable job on early episodes. Eisner's influence was strong over all of the artists in the beginning, and *The Spirit*'s art and stories were created to be similar to Eisner's creative sensibilities. In time, however, Fine redirected his interests. Like Eisner, Fine wanted to expand his drawing abilities beyond "kiddy comics" into other, more adult themes. This included exploring the fields of syndicated newspaper strips and advertising.

But as Fine's natural drawing style took over, it began looking less like something that would reflect Eisner's original intentions with *The Spirit*. Soon it was apparent that Fine's work was ringing less and less true to Eisner's original vision.

Without Eisner's keen eye to look everything over, each week the three features were sent to Arnold's Stamford, Connecticut, offices before going on to the printer in Buffalo, New York. Eisner suspected Arnold rarely gave the work more than a cursory review.

The substitute "Eisners" did a credible job, and Arnold reported at one point that the syndicate was happy and no papers canceled the feature. Critical reviews, though, note that by 1945, the feature was creatively a sad reflection of what it was in 1942 and it desperately needed Eisner back at the helm.

The most significant change was the deletion of Mr. Mystic in 1944. Powell, like Eisner, had entered the service and the feature was continued by the veteran writer/artist Fred Guardineer beginning with the October 10, 1943, installment. The five pages were ultimately replaced after May 14, 1944, with comical

features produced by studio mates Andre Le Blanc, Al Stahl, and Robert Jenney. None of these proved popular enough to claim the spot in perpetuity.

The daily, which never quite gained a reputation, also quietly faded away after the March 11, 1944, installment.

Joe Dope

Meanwhile, the time Eisner spent at the Ordnance Department proved fortuitous since reorganization led to it becoming a department with a mandate to teach the troops preventive maintenance.

Word got around to Aberdeen since it was also a training center, and Eisner started to imagine how comics could illustrate a new and very different subject matter. At that point, Eisner was totally convinced that the medium was one that could lend itself to more than just adventure stories. In fact, the average soldier would probably respond well to training manuals if they were done in a comic style. Eisner was immediately convinced that he could delight the soldiers as well as instruct them. With this in mind, he pitched his idea to his lieutenant colonel, who was also his boss in charge of the newspaper.

Soon Eisner was transferred to Holabird Ordnance Depot where he helped start a magazine called *Army Motors*, a hands-on field publication with a spotlight on preventive maintenance for army vehicles, arms, and other military equipment.

To help educate the troops and give them someone to identify with, Eisner created a new character, the soldier Joe Dope. Joe Dope reported to Sgt. Half-Mast

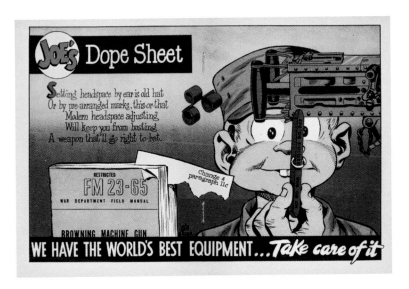

Eisner's popular character Joe Dope was first seen in an early army strip and then on instructional posters. Joe Dope finally appeared in his own two-page strip in 1944, in the army magazine, Army Motors. The stories that Eisner created combined humorous anecdotes about being in the army with useful, practical advice about repairing engines. This image was taken from a 1955 edition of P*S, the Preventive Maintenance Monthly, a magazine Eisner produced as a civilian until the early 1970s.

McCannick, and for years, Joe Dope and his female counterpart, Connie Rodd, helped teach engine maintenance basics. The character appeared not only in the magazine, but on posters found around barracks on both sides of the Atlantic Ocean.

Joe Dope proved so successful that in a test conducted by the University of Chicago, the comics approach was found to be more effective than the traditional prose-only manual. Eisner's long-held belief that comics could be entertaining and educational was finally proven true.

Eisner himself was subsequently transferred to the Pentagon in Washington, D.C., where he served as a warrant officer for the chief of ordnance, General Campbell.

Just before being discharged, one syndicate asked Eisner to consider turning the army comics into something for the home front readers. He began to develop something called *General Poop*, but it got no further than a title.

Home at Last

Late in 1945, Eisner was discharged. He returned home, twenty-eight years old and ready to get back to comics full-time. With Fine obviously interested in other features, Eisner found new artists with whom to surround himself. One could imagine the creator rubbing his hands together in anticipation at drawing that first *Spirit* Sunday section.

The timing couldn't have been better as the first all-Eisner feature, "The Christmas Spirit," was scheduled for December 23. Eisner had started producing annual Christmas stories in 1940, although his assistants abandoned them during the war, and it was a wonderful time to come back to the seasonal feature. It was everything people loved about the strip—crackling layouts, detailed artwork, and a humorous, touching story. Eisner was back and clearly happy to be there. He was determined to improve the strip's quality, which upon rereading, had obviously fallen upon hard times.

The syndicate asked that the first year or so stay on the lighter side, letting Americans adjust to a postwar world. Eisner complied, and the feature was, for a while, an entertaining, breezy read.

The grind of producing a weekly feature plus running a studio required Eisner to use assistants for the life of the strip. In American syndicated strips, this practice is considered normal, unlike comic books and graphic novels in which people tend to get credited for their work. Among the new assistants were artists John Spranger and Jerry Grandenetti, letterers Martin Muth and Abe Kanegson, and writers Marilyn Mercer and Klaus Nordling. The majority of the work was still done by Eisner, who carefully supervised the entire project.

In his second week back, Eisner recapped the Spirit's status quo (his job and relationships with friends and foes alike), perhaps as much for himself as for the readership. He also brought back five previously introduced foes, clearly reclaiming his place. It marked the final appearance of the quick-change artist the Squid, setting the stage for the arrival of the Octopus on July 14, 1946. The interesting thing about this villain is that he's seen only as a uniquely gloved hand or silhouette, never in the clear light. Comics historian N. C. Christopher Couch, who teaches at the University of Massachusetts, Amherst, noted that the villain was an "Eisnerian metaphor for the continuing influence of Fascist ideology after World War II who poisons urban water supplies and steals atomic secrets, and is opposed not only by the Spirit, but also by organizations with an international scope including the United Nations and an insurance company modeled on Lloyd's of London."

MOSTLY THEY'RE GONE NOW, THE OLD TROLLEYS... JUSTAFEW STILL RUN ...LIKE THE OLD RAVENS POINT LINE, FOR EXAMPLE !!..

All day long, like drunken bugs, the creaky jallopies waddle their way through the noisy city, loading up with morning crowds which come back the same way at night....

THE SPIRIT

BY WILL EISNER

IN the dark valleys of the underworld, where men laugh at the law and only the nimble survive, one man stands as a constant threat to the security of those whose cunning enables them to outwit the police! There are many to testify that even DEATH cannot halt The SPIRIT!

Eisner often employed fanciful and elaborate treatments to *Spirit* typefaces in order to foreshadow the plot of individual stories, such as in this splash page from March 24, 1946. Among the first cartoonists to render lettering in a way that contributes to his narrative, Eisner's *Spirit* is now considered a pioneer among the comic strips of its day.

Eisner's writing grew sharper, and his stories better communicated the O. Henry style (i.e., poignant stories with surprise endings) he had always wanted from the beginning. Everything before the war can now be seen as a mere warm-up for the real stories. Almost every character introduced was unique, as far from central casting as you can get. As a result, readers never knew what would happen from one Sunday to the next.

In viewing these stories, the *Washington Post Book World* noted, "Eisner's formal experiments opened up new territory for American comics." The title page of each story, in particular, is a little wonder of design— the Spirit's name might be spelled out by scraps of paper drifting over an industrial zone, a set of lipstick prints, or the ripples in a whirlpool. Eisner discarded realism in favor of hyper-expressive body language and loose, rubbery line work. He played with wide-open spaces on the page, wordless sequences, and elaborate framing devices. From a twenty-first-century perspective, these stories are snapshots of postwar American culture trying to make sense of its own absurdities.

In addition to the Octopus, the Spirit began encountering exotic, albeit dangerous, women. The most noteworthy is probably P'Gell, who arrived on October 6, 1946. This French woman held a variety of jobs from thief to mother and, like Sand Serif, always caused the Spirit's temperature to rise even though he was perhaps the only man to resist her. She had a habit of marrying frequently, especially because none of her mates lasted long after the nuptials.

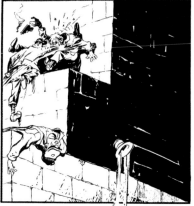

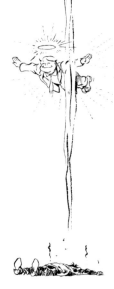

AND SO... LIFELESS...
GERHARD SHNOBBLE FLUTTERED
EARTHWARD.

BUT DO NOT WEEP
FOR SHNOBBLE...

RATHER SHED A TEAR
FOR ALL MANKIND...

FOR NOT ONE PERSON IN THE
ENTIRE CROWD THAT WATCHED
HIS BODY BEING CARTED AWAY...KNEW
OR EVEN SUSPECTED THAT
ON THIS DAY GERHARD SHNOBBLE
HAD **FLOWN**.

These drawings, among Eisner's personal favorites, feature the
Gerhard Shnobble character, who appeared in the September 5, 1948,
issue of *The Spirit*. In the story, Shnobble, a security guard for a bank,
gets fired from his job because of his ineffectiveness during a bank
robbery. Distraught at the situation, Shnobble enters a nearby
building only to throw himself off its roof, thinking he could fly.

On September 5, 1948, Eisner introduced readers to a dreamer named Gerhard Shnobble. His story is perhaps the most often cited example of Eisner's *Spirit* at its best. As proof of its popularity, Eisner designed a mural from this work that was painted on a building in Copenhagen, Denmark, in 1996.

One of the other things that Eisner's army experience taught him was that African Americans were being unfairly portrayed in American mass media. Artist Jim Vance wrote in *The Spirit Archives* volume 14, "In the case of 'Bebop,' the problem runs deeper A humorous take on postwar black hepcats, it relies on ethnic stereotyping that makes Eisner cringe today. Its star is Ebony White, a character who could never escape the stigma of racial caricature no matter what his creator did with him. Ebony was a valuable member of the cast, the best loved of the Spirit's three sidekicks, and by far the most human . . . but his design and dialect were pure minstrel show." Eisner finally sent the youth off to school in 1946, and Ebony was rarely seen again until years later. After that, Ebony was replaced by the less stereotypical youth known as Sammy.

At its height, the feature appeared in only twenty newspapers around America with a combined circulation of 5 million readers. Yet those who read it loved it. The high level of quality Eisner produced on a weekly basis impressed his peers.

While still in the Ordnance Department, Eisner met musician Bill Harr. After the war, Eisner asked Harr to write a melody that appeared in the feature from time

to time. Sheet music was finally published for "Ev'ry Little Bug" in 1947, but it took until 1987 before it was published by Kitchen Sink Press.

Commercial Art

Eisner's war experiences also fueled his desire to push the idea of educational comics. As he continued to run the studio, he founded a commercial operation called American Visuals. Sears, Roebuck & Company was an early client, developing the idea of a monthly comic give-away for customers. Eisner created the *Ruff and Reddy* feature, which he drew with Grandenetti. After completing one issue, Sears shelved the notion. American Visuals produced books for, among others, the Baltimore, Maryland, chapter of the American Medical Association.

Eisner also wanted to do other comic strips, and one of his frustrations during this time was the failure to sell any of them. The main character for *Nubbin the Shoeshine Boy* was envisioned as a male Little Orphan Annie, but was rejected by numerous syndicates in 1946. Eisner loved Nubbin and found ways to work him and his characters into other features. Nubbin, for example, would have been a backup feature in the Sears comic. Finally, Eisner stopped trying to revamp the material on its own and incorporated much of it into several *Spirit* stories as late as 1950.

Eisner also tried to become his own comic-book publisher. Seeing that there were few sports comics on the newsstands, he created *Baseball Comics* in 1947. The title featured Rube Rooky as the lead hero, a

reworking of the Fireball Bambino character from Nubbin. At the time, the most popular sports comic strip was *Joe Palooka*, about a boxer. Rooky was to be a comic-book *Palooka*, a hick and innocent who must persevere in a rough and tumble city. Jules Feiffer, who had joined the studio in 1947 and became its most talented writer after Eisner, wrote the feature. Back-up stories were about actual classic baseball games.

Baseball was joined on the racks by *Kewpies* with plans already made for *Pirate Comics* and *John Law, Detective*. *Kewpies* featured nothing by Eisner, but was more a Feiffer vehicle including the first appearance of his Clifford character. *Pirate* would have been a return to Eisner's earlier *Hawks of the Seas* days, while *John Law* was a variation on *The Spirit*, with Nubbin as a regular character.

None of the titles performed well given their poor national distribution, and all were canceled after one issue apiece. Some never made it out of the studio. The *John Law* material got reworked into several 1950 *Spirit* stories with femme fatale Sand Blue turned into Sand Serif. Clifford, though, became the new eight-page supplement to *The Spirit*. But while the comics failed, Eisner's commercial work increased and was starting to demand more of his attention.

AFTER THE SPIRIT

As the 1940s gave way to the 1950s, Eisner was directing more of his energies toward commercial art. American Visuals had taken on General Motors, RCA, New York Telephone, and the U.S. Job Corps as clients, and Eisner continued to envision educating people through the graphic medium.

The army decided to scrap its magazine *Preventive Maintenance* and replace it with something else. Given his experience, Eisner was the ideal candidate to produce the 1951 replacement, *P*S, The Preventive Maintenance Monthly.* Joe Dope returned to duty, along with Connie Rodd and Sgt. Half-Mast McCannick in a regular eight-page feature in the digest-sized publication. Eisner did most of the work himself, slowly letting his assistants do more work on *The Spirit*. Dan Zolnerowich, a former *Sheena* artist, came aboard to work with Eisner and Klaus Nordling.

The market was changing, as was the economy, with paper and printing prices increasing. The Sunday section was past its peak in terms of popularity, so Eisner was feeling its time had passed. As a cost saving measure, the sixteen-page section was reduced to eight with *The Spirit* taking only four pages. He had stopped doing most of the work and handed it off to his studio, with Feiffer writing most of the stories and a newcomer, Wally Wood, handling the art. Their most celebrated story, given Wood's skill with people and machinery, was a science-fiction tale, which was also reflective of 1950s American society.

"[Feiffer] added an intellectual stimulus that enabled me to expand on the 'grown up' focus to which I aspired," Eisner wrote in *The Spirit Archives* volume 6. "The staff grew to include an innovative and brilliant lettering duo, Abe Kanegson and Jerry Grandenetti, who came out of an architectural company and provided the feature with sophisticated backgrounds that supported the theatrical staging. I now needed to address the current rhythm in American readership, to move from film orientation to a greater realism that one finds on the stage. I also wanted to keep abreast of social humor which was rapidly maturing."

Switching Gears

Wood was having trouble making the deadlines, and that decided things for Eisner. He had just gotten married, the

studio had contracts that were far more lucrative, and his beloved hero was suddenly becoming a burden. The Sunday section was discontinued, without ceremony, after the October 5, 1952, installment. The twelve-year run was certainly healthy, but Eisner thought that was enough, and he was done with his creation.

Fiction House continued to reprint the Sunday sections in comic books for a while longer, having picked up the feature after Quality folded, selling many of its characters to DC Comics.

Eisner and his studio now shifted from comic books to entirely comic stories for commercial clients. It was also at this time that Eisner was pitching educational comic stories to various elementary schools, trying to persuade them to drop their prejudice against the medium. Ultimately, what educators learned is that students like comics and will actively read them.

*P*S* took up the majority of Eisner's time, with his staff of eight producing the comic stories and relying on an army staff of twenty-four to determine what needed to be covered in each issue. The simple messages, such as "Keep your jeep clean," or "Keep your pistol oiled," were portrayed in an engaging manner. Cat Yronwode noted in the *Will Eisner Reader*, "The first few years of *P*S* are distinguished by some fine work by Will Eisner, particularly his parodies of *Dragnet* (called *Hairnet*) and his use of film noir effects to add surreal 'drama' to a plug for careful engine lubrication."

As part of his agreement, Eisner was required to go overseas and into the field at least once or twice per

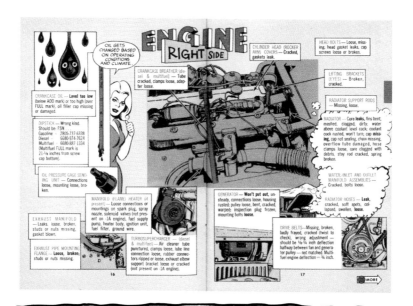

In this example from a 1967 issue of *P*S The Preventive Maintenance Monthly*, Eisner demonstrates how well the comic medium lends itself to creating interesting, entertaining, and instructional material. While in the army Eisner drew educational comic strips for soldiers' manuals. As a civilian he continued drawing educational comics for *P*S* well into the 1970s.

year. Observing mechanical work in real life helped him shape his drawings in an authentic way. Eisner's experiences overseas not only helped him produce the magazine for two decades, but stayed with him for use much later.

Beyond *P*S*, he continued to draw for others, including RCA, for which he drew a light-hearted series of paper record sleeves called Gleeful Guides. When the touch-tone telephone was introduced in 1963, New York Telephone had Eisner create a character named Rip Roscoe to promote its new device.

Eisner continued to dabble with spot cartoons. Several were later collected, along with several of the Gleeful Guides pieces in the 1970s, and released as paperback books for youngsters, which sold for many years through school book clubs.

It was a quiet time for Eisner, who thought he was doing what he wanted. Things were stable at work, he was newly married, and he was doing less and less art.

In 1965, Eisner was named president of Bell-McClure Syndicate. As its leader, he tried to improve the salaries of comic-strip artists as newspapers ran fewer features in a smaller space. He soon developed a disdain for newspaper editors and even the syndication business itself.

The Spirit, though, refused to remain quiet. Harvey Kurtzman, the brilliant writer and artist, was editing the humor magazine *Help!* and called Eisner to secure reprint rights to *The Spirit*. They agreed to reprint one of the seven-page stories in *Help!* number 13, in February 1962.

Feiffer soon after wrote an article about comics for *Playboy* magazine in 1965. The pop-culture craze of the era was under way, and suddenly superheroes and comic books were in vogue. The article was so well received, Feiffer expanded the piece into the book the *Great Comic Book Heroes*, which featured the original essay along with selected reprints from DC, Marvel, and Fawcett, including a *Spirit* story.

A year later, Harvey Comics tried a new title featuring *Spirit* reprints, which lasted only two issues. Notably, Eisner wrote and pencilled a new seven-page

story for each issue, inked by Chuck Kramer. Today, those comics command high prices among collectors.

On January 9, 1966, the *New York Herald-Tribune* asked Eisner to do a new *Spirit* story to comment on the mayoral election, which John V. Lindsay won for a second term. The five-page story showed Ebony as an adult civil servant and Ellen Dolan as the new police commissioner. It was classic Eisner.

Eisner remained only vaguely interested in comics, concentrating on his other commercial art jobs. By the end of the 1960s, he was the chairman of the board at Croft Publishing in Connecticut.

A new spin-off company from American Visuals, Educational Supplements, allowed Eisner to focus on commercial publishing with supplemental material for classrooms. Eisner described the thinking behind his efforts in *Shop Talk*, "I was into this in the 1950s and 1960s, when I was selling on that basis to schools. I said, 'Look, you may not like comics, but your students will read them.'"

In fact, sometime around 1970, Eisner recalled to *Comic Book Artist*, "We were publishing a series of comic books called *Job Scene* in which we introduce the work ethic, so to speak, to young high school dropouts. We were using the comic medium. [DC president] Carmine [Infantino] asked me if I'd be interested in selling or merging with DC, allowing them to acquire the company. As a matter of fact, [Marvel Editor-in-Chief] Stan Lee had the same interest at the same time, but I was not interested."

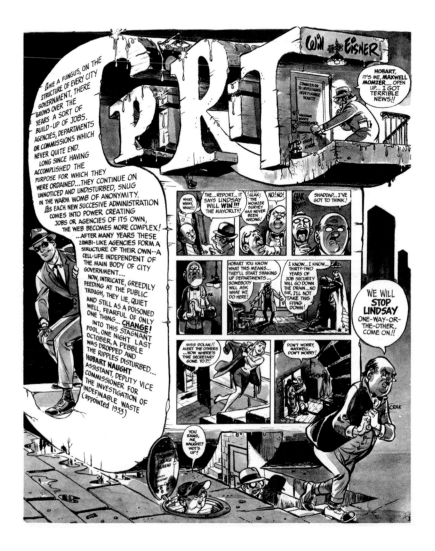

The *Spirit* returns on Sunday, January 9, 1966, in the magazine section of the *New York Herald-Tribune*, the first new *Spirit* story in fourteen years. The five-page story, written and drawn by Eisner, details a plot against Mayor John Lindsay from getting reelected in the New York City mayoral race. In the story, Eisner satirizes other politicians in the race, too, and uses the names and likenesses of Abe Beame and William F. Buckley Jr.

Igniting the Creative Flame

Without his realizing it, the pop-culture movement led to a series of successful comic-book conventions, mostly in New York City, where DC and Marvel are located. As Eisner recalled in *Shop Talk*, he told convention organizer (and high school teacher) Phil Seuling, "Well, I came back into the field because of you. I remember you calling me in New London, [Connecticut] when I was sitting there as chairman of the board of Croft Publishing, Co. My secretary said, 'There's a Mr. Seuling on the phone, and he's talking about a comics convention. What is that?' She said, 'I didn't know you were a cartoonist, Mr. Eisner.' 'Oh yes,' I said, 'secretly I'm a closet cartoonist.' I came down and was stunned at the existence of a whole world. That's where I met Denis Kitchen. This was a world that I had left, and I found it very exciting, very stimulating."

That 1972 experience showed Eisner that things were changing and his dream of using the comics format to tell stories was coming closer to happening. At that convention, Eisner met Kitchen, an underground cartoonist who was also a successful publisher of such comics. This led to Kitchen Sink Press releasing two issues of *Spirit* reprints.

A year later, Eisner took a year's assignment as a cartooning instructor at Sheridan College in Ontario, Canada. His class created a new *Spirit* story, "The Invader," which was subsequently published by Tabloid Press in 1973. Eisner discovered that his years

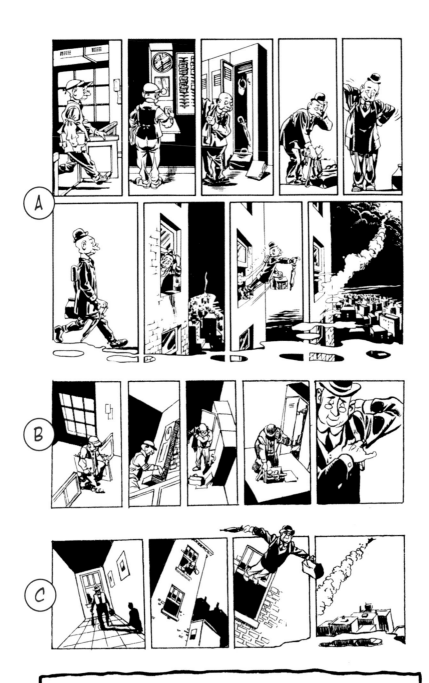

In this example from *Comics and Sequential Art*, Eisner explains how he decided to give this nine-panel story a more visually dramatic ending. In the top sequence (A), the comic has less impact because Eisner maintains the same perspective throughout the strip. In the bottom sequences (B, C), Eisner uses changing perspective to add drama. The book's content is based upon Eisner's experiences teaching sequential art at the School of Visual Arts over a nineteen-year period.

of guiding artists in his studio made him an excellent instructor. In 1974, he began a nineteen-year tenure with the School of Visual Arts in New York City.

"After 1952 [and] until 1964, *The Spirit* had no value as far as I was concerned," Eisner told Jon B. Cooke in *Comic Book Artist*. "I kept the artwork for some reason and it was just lying in storage. (I am one who just doesn't like to sell his original artwork.) As a matter of fact, I kept it in a vault and held on to every one of those stories—I had 250-odd stories."

Immediately after the Kitchen Sink reprints, Stan Lee asked Eisner about his creation joining the Marvel Universe. While Eisner thought about the surprising offer, weighing the time it would require against his work at American Visuals, James Warren, a successful publisher of black-and-white magazines featuring horror stories with O. Henry–style twists, contacted Eisner to reprint several *Spirit* stories. At the time, Eisner was more comfortable with the second arrangement.

Eisner asked Warren to buy back the reprint rights to the Kitchen material and then set up a new deal. The response was so positive, a magazine was launched, and suddenly, in 1974, Eisner was back in the comics business on a regular basis.

At first, the stories ran as color inserts in *Eerie*, but the response was strong enough for the character to headline his own title.

The Spirit magazine was a bimonthly in black and white, with Eisner supplying the proofs and new color covers. "I prefer *The Spirit* in black and white—I prefer

all of my work in black and white, to be honest with you. I believe the black line is a more pure contact with the reader. Color tends to obliterate or interfere with the flow of the story. I try very hard to make emotional contact with my reader early and to maintain an intense relationship [with him or her] as the story goes on. I find that anything that interferes with that is counterproductive," he told Cooke.

Warren editor Bill DuBay chose the stories in a haphazard manner, which annoyed Eisner who would have preferred a chronological approach. But new fans unfamiliar with the character were eager for whatever Warren published.

Eisner considered his relationship with Warren a cordial one, although they did disagree on occasion about covers, including one time when Eisner reacted badly to a design made by one particular pulp cover artist. Although Eisner was known to be easygoing with publishers, he forced Jim Warren to switch artists.

In an attempt to pay tribute and cross-promote the *Spirit* characters, DuBay wrote a few stories in *Vampirella*, illustrated by Ramon Torrents, which were set in Wildwood Cemetery. They involved Denny Colt being placed in suspended animation and a key figure in a murder mystery.

But when Warren ran into financial difficulties in the mid-1970s, he canceled the title. Eisner was interested in keeping the character in print, so he turned back to Kitchen. He explained to *Comic Book Artist*, "It happened almost immediately. Denis [Kitchen] had

Cartoonist, writer, and publisher Denis Kitchen (left) is seen with Eisner in this contemporary photograph. At the time, Kitchen was publishing much of Eisner's catalog through his company Kitchen Sink Press, which he closed in 1999. Kitchen had published a variety of comic artists and more than twenty of Eisner's graphic novels, more than 100 Spirit comics, and the Will Eisner Quarterly.

originally done those couple of *Spirit*s before Warren [Publishing had], and by the time the Warren *Spirit* discontinued, Denis had built his little publishing company into something a bit more substantial. He said he would like to continue *The Spirit*, and I said, 'Fine. I'll go back with you.'"

THE SPIRIT OFF THE PAGE

As popular as *The Spirit* was, it never made it off the comic page during the golden age of comics. While Superman had a radio show and Captain Marvel had a movie serial, there wasn't much interest in the Spirit. Eisner recalled in *Comic Book Artist*, "Columbia Pictures came to me between 1952 and 1955 and offered to do a television series on the Spirit—but they stipulated conditions which I felt were absolutely humiliating so I just walked out of the meeting."

While his own creations Sheena and Blackhawk have been filmed, it took a while before Central City's protector got his turn.

It was 1987 when the Spirit finally made it on the air in a poorly received television movie that acted as a pilot for a weekly series. Sam J. Jones was perhaps miscast as Denny Colt, and the production lacked Eisner's wit and pathos.

Feature film rights for the *Spirit* have recently been acquired by Odd Lots Entertainment in partnership with Batfilm Productions. Although Eisner had said in prior interviews that he was uninterested in making a film version of the *Spirit*, he is pleased with the plans for the adaptation of his most famous work.

At the same time, in 1976, Eisner produced, for Tempo Books, *The Spirit Casebook of True Haunted Houses and Ghosts*, a 160-page book with the Spirit acting as host.

Kitchen Sink Press ensured that the Eisner material was collected in order, with several tie-in titles and art books along the way. Kitchen handled the material with such affection that after the publishing company ceased to function, he became Eisner's trusted agent.

In the late 1990s, DC Comics acquired rights to *The Spirit* and many of Eisner's graphic novels, releasing them under the umbrella title of the *Will Eisner Library*. Few comic artists have produced a worthy body of material for such a designation.

EISNER THE GRAPHIC NOVELIST

The 1970s saw several changes for Eisner. He rediscovered comics as a medium and chose to sell his companies. *P*S* went, after twenty-six years, to a former Eisner employee, Murphy Anderson, who continued to produce the magazine through his Visual Concepts company for another decade. Former studio mate, Joe Kubert, began producing art for *P*S* within the last decade.

Eisner also continued to teach. He enjoyed lecturing and working with eager artists at New York's School of Visual Arts. These lessons also were turned into "chalk talks" given at conventions around the world, where Eisner was a fixture for many years.

Eisner also turned many of his lessons into two invaluable textbooks. The first was *Comics and Sequential Art*, considered by many comic-book

artists to be the definitive book on the graphic story-telling process. His subsequent volume was *Graphic Storytelling*.

A Contract with God

Eisner, in the 1970s, turned his Gleeful Guides into four paperbacks, and then directed his attentions to his first original book. While considered the first modern graphic novel, *A Contract with God* is actually a collection of four interconnected works. However, selling the work to a book publisher was a challenge. After several attempts, and in situations where Eisner referred to the manu-script as a comic book, he got little response. It was only after Eisner coined the term "graphic novel," that he got some attention. Eisner finally found a willing publisher with Baronet Books, which printed *Contract* in sepia tones in 1978.

Alan Moore wrote in his introduction to *The Spirit Archives* volume 1, "In this intensely involving assort-ment of stories, Eisner has managed to study the microcosm of a tenement neighborhood and pick out some remarkably human stories for inspection. We have the tale of a street singer busking for money who encounters a failed singer looking for love. We have a study in different kinds of monster with 'The Super,' a story concerning a clash between a little girl and the superintendent of her aunt's building. We have the title story itself, a bitter tale of lost faith played out against a background of rumbling urban thunderstorms." Even

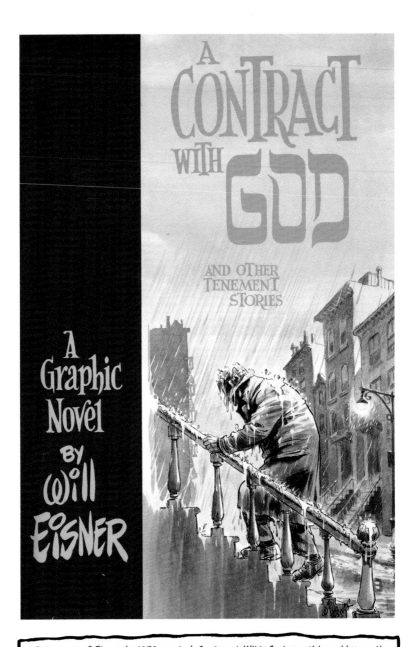

The cover of Eisner's 1978 work *A Contract With God*, considered by most to be the industry's original graphic novel, is seen here. Eisner has been an inspiration to generations of established illustrators and comic artists as well as up-and-coming talent. Both Frank Miller (*Sin City*, *Batman: The Dark Knight Returns*) and underground comix artist Robert Crumb (*Zap Comix*, *Home Grown Funnies*, *XYZ Comics*, *Mystic Funnies*, *Waiting For Food*) have called Eisner a "major influence."

today, *A Contract with God* remains one of the medium's most audacious strides in freeing comics from the reign of superheroes to human stories of love and loss, of tragedy and suspense, and of surprise and sincerity. From a very early age, Eisner saw the vast potential of the comic medium. He took every chance to break comics out of their mold into an adult format that would eventually lead to mainstream literary fiction, films, and most every other artistic media.

The *New York Times* pointed out that *Contract* established Eisner as the father of a new form. People in the comic-book world were stunned by its maturity, while bookstore buyers weren't sure what to make of it.

Although Baronet Books wasn't a company known to comic-book readers, fans of Eisner's tracked *Contract* down anyway, and the book was a hit. *Contract* was a mature and intimate work of comic fiction, and it hit the market with astonishing impact. It was one of Eisner's most relaxed works. One look at the title showed readers and critics alike that the graphic novel was a format that Eisner had been contemplating for a very long time.

Private Stories

Undaunted by the small initial sales, Eisner set to work again, producing one story after another, building up a library of graphic works that explored the human condition. Most of these works are set in the past, drawing from Eisner's rich experiences living in the

tenements. Initially these graphic novels were published in the United States by Kitchen Sink, but after the company folded in 1999, Eisner spread himself among several book publishers.

Similar to William Faulkner's fictional Yoknapatawpha County, many of Eisner's stories occur in and around Dropsie Avenue in New York City. The books also play with the storytelling format with some occurring over several years in the same place (*Dropsie Avenue*, the *Building*) or stories occurring entirely in vignettes and flashbacks (*Minor Miracles*).

In an interview with Italy's Radio Città del Capo, Eisner discussed the thinking behind his personal graphic works. "Well, I do get older. And somehow some of the memories seem to hit me like out of a bookshelf. And they are all encapsulated. As a matter of fact, as I learned when I wrote *To the Heart of the Storm*, which is autobiographical, and I was reaching back in my memory to find the things related to my story . . . well, I found that my memories were in [a] series of panels. They were all encapsulated in panels, you know? You remember one single incident by knowing the before or the after. And that's largely because our life is a seamless flow of incidents."

He went on to muse on another theme that runs through his work, dating back to the earliest *Spirit* stories. To him, "the enemy is life because instinctively all human creatures are in a struggle to survive. Survival means to avoid death. Their life is a series of incidents that affect the survival of everybody by doing good or

bad. If something good happens it is because it adds to the comfort of your life, something bad happens when it threatens your mortality."

Eisner's storytelling approach also adapted to the new form. "I was dealing with a reader that I felt was more sophisticated than a comic-book reader. By creating a series of pantomime panels without dialogue, without balloons, I'd get the reader to supply the dialogue. This medium requires intelligence on the part of the reader. It requires contribution, participation. This does not occur in movies, for example. This is the prime difference between comics and film: Film is a spectator medium, while comics is a participatory medium. You participate, your reader contributes to it, and you have a sort of dialogue with the reader. And the reader is expected to draw out of his or her life experience the things you're suggesting or alluding to," he told the *Onion*.

To Eisner, *Contract* was like his first child. He often commented in interviews that it is his most personal work to date. And it remains contemporary. *Contract* is still in print in many languages around the world. In 2003, Italy saw the popularity of using novels packaged with newspapers to improve circulation. In 2003, to boost readership of the newspaper *La Republica*, it began excerpting novels as an incentive. One of these premiums was an edition of the book, now twenty-five years old, which surprised Eisner. Today, *Contract* remains as fresh and poignant as it was a quarter century ago, especially since he is reaching both adult and

young adult audiences, something he always suspected would happen.

Another major difference between Eisner's earlier work and his current projects has been the decision to eschew color in favor of black and white. (Or, in the case of *Contract*, sepia and white.) For that first graphic novel, he insisted on that color because, "It has a dreamy quality. Psychiatrists have told me that people dream in brown. I don't know how true that is. I think I dream in black and white. But [sepia tones] create warmth, and it's not as strident as harsh black and white. A lot of my books have been in black and white. For instance, *To the Heart of the Storm* was all in black ink. That seemed to work there," Eisner told the *Onion*.

Eisner has always said that he preferred working in only black and white because of its intimacy. The sharp lines on the page, in his opinion, reach the reader without interruption. Eisner believes that working in color presents too much interference to a reader. In his opinion, color can be too distracting and has a tendency to interrupt the dialogue in a story. He continued this theory in the *Onion:*

Color is almost like a large orchestra playing behind the art, you know? You can't hear a thing. I don't think color is bad—I've used color in the fairy-tale stories and I'll use it on covers—but I don't feel I need it inside the book. In . . . *A Family Matter*, I used the brown coloration: not full color, but monochromatic color, largely because I wanted to create a

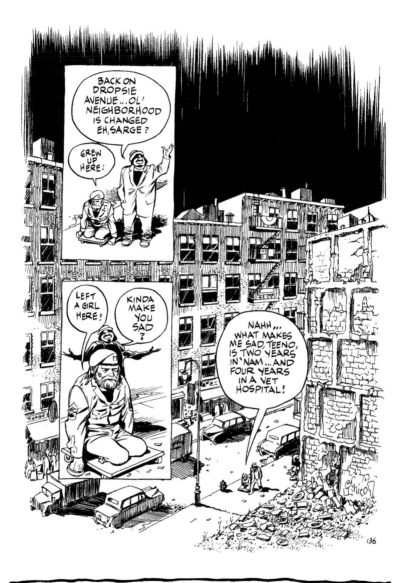

In this drawing from Eisner's 1995 graphic novel *Dropsie Avenue*, a Vietnam vet named Sarge is about to inherit the Dropsie beat from Crazy Bones, a character in the city jail who is being held for drug dealing. Eisner's story details the rise and fall of a city street over the course of a century.

mood. Color does help create moods. I like a lot of my books to run in brown ink rather than black ink.

Additionally, by producing his current works as novels or extended short stories, Eisner can play with the panel arrangements. This freedom allowed him to experiment with the pacing of his stories. For example, in *Contract*, he abandoned the basic rigid panel layouts people were familiar with in favor of a more open, impressionistic approach. The panel borders were gone, adding more "air" to the page.

One of Eisner's early influences was George Herriman, the creator of the 1920s comic strip *Krazy Kat*. It was from Herriman's surreal artwork that Eisner learned about the importance and power of a strip's background to create an appropriate atmosphere for his characters. In Eisner's opinion, if you give the reader a blank background, then he or she has a tendency to visualize whatever he or she wants. The reader ultimately imagines something out of his or her own imagination or experience.

BREAKING NEW GROUND

Encouraged by the reception to his first graphic novels, Will Eisner set about producing a steady stream of them, each a personal reflection. Among them was his noteworthy and autobiographical the *Dreamer* (1986), which told the story of comics' early days. (Iger always called Eisner a dreamer, hence the book's title.) Before Michael Chabon wrote the *Amazing Adventures of Kavalier & Clay*, Eisner told the story of unscrupulous publishers, starving artists, and the still-forming world of comic-book publishing. Fans were able to easily determine the identity of each character, although that was an added treat after the book's strong drama, which resonated with all its readers.

In 1987, Eisner dipped further back into his memory and told stories in the *Building* and *New*

York, the Big City, both shorter works collected from the pages of the short-lived *Will Eisner Quarterly*, which mixed new fiction with his later-collected *Shop Talk* interviews. The collections showed a broad range of views on New York's inhabitants, not just Jewish immigrants, but a broad spectrum of personalities.

For a change of pace, *A Life Force* (1988) took the broad topics of the Great Depression and the rise of the Nazi Party in Germany, and showed their combined effects on a typical Bronx tenement and its inhabitants.

His *City People Notebook*, a year later, showed Eisner's virtuoso flair for storytelling with vignettes, largely told through pantomime.

For Eisner, this was a chance to stretch a bit. He explained to silverbulletcomicbooks.com columnist David Gallaher:

When I started working on *The Spirit*, film was the major communication medium. Something happens to popular reading habits when it is impacted by a medium like film or radio or television. It affects the reading rhythm of the audience and those working in communication must be conscious of the reading rhythm of their reader. If you lose contact with the reader, you are doing a disservice to [him or her]. It is much like trying to tell a story to a man running on a treadmill. If you adjust the way you tell the story, to his kind of rhythm, you communicate more effectively. When I came to the end of doing *The Spirit*, I realized that I was telling a story to an audience whose attention span had been affected by film, so I began to

In this drawing of Eisner's from the *Building*, a graphic novel from 1987, the ghosts of four dead urbanites tell the story of the life and death of a city building. These panels detail the comings and goings of Mensh, a character who wants desperately to help Chico, a young street criminal, after he witnesses the death of a child in a car accident.

employ aspects of film into my stories. Later, when I started *A Contract with God*, I went back and decided to look at the elements of live theatre to get closer to the characters and closer to their reality.

Again, Eisner was trying to achieve a higher level of intimacy with his readers. In his opinion, comics are a participatory medium, while film is one where viewers are detached. While movies are timed to invoke a virtual reality, someone reading a comic book can read, reflect, and read again. He often says that he wrote *Comics and Sequential Art* to help explain the differences between comics and film. In Eisner's opinion, comics are much more than movies on paper, as they have at times been described.

Once again, using his own life for inspiration, Eisner released *To the Heart of the Storm*, this time exploring the rise of anti-Semitism in America during the waning days of the Great Depression and into World War II.

After producing a steady stream of graphic novels for twenty years, Eisner took a detour, producing some shorter, less personal works that took him full circle. One of these proposed contracts was for Florida's Public Television network, which asked to work with Eisner on a literacy project. Eisner went back to classic literature and condensed the stories, providing the illustrations for several thirty-minute programs. Instead of animating the figures, the words they spoke were animated. Public Television liked the

WELL AHEM WHAT ER SURPRISE, MR. LUARDI... YOU ARE JUST IN TIME FOR SUPPER!

City People Notebook (1989) gives an intimate treatment to the subtleties of living in a large city, including being cramped in close quarters with little privacy, smelling the streets during the heat of the summer, remaining completely anonymous in a crowd, and dealing with constant noise.

idea and encouraged Eisner to keep working on layouts while it sought funding. But because no one shared enthusiasm for the project, it was abandoned. Eisner, though, asked his agent in Europe to see about finding a publisher for these books. Given the reception his other works have received, there was no trouble securing interested parties.

In 1999, NBM (Nantier, Beall, and Minoustchine) Publishing brought several of Eisner's children's books

to American readers, including *Moby Dick*, the *Princess and the Frog*, the *Last Night* (about Don Quixote), and the *White Whale*.

That seemed to encourage Eisner to move away from his autobiographical work and on to other similar stories in keeping with his traditional themes. *Last Day in Vietnam* became a bridge from Eisner's personal work to his newer themes, this one drawn from his annual overseas trips while producing *P*S*. As he had said many times, there were often stories and ideas kicking around in his head that he was tempted to explore but never had the time. After flipping through some *Spirit* books one day, an idea occurred to him to investigate a plot he'd created years earlier.

"[In] *Last Day in Vietnam*, I experimented further in having the reader become part of the story itself," Eisner said to the *Onion*. And readers responded. The title was awarded Best Graphic Album of Original Work at the 2001 Harvey Awards, one of two comics industry awards.

While producing a variety of works, Eisner also spent six years slowly crafting a dark, personal story released in 2001 as the *Name of the Game*. The plot examined the world he grew up in and the varying economic successes of the Jewish immigrants in New York who all came from different European countries and had various social stresses.

In 2002, Eisner wrote another folktale, though this time, it was African in origin. NBM published *Sundiata: A Legend of Africa*, which came from a tribal legend from the people of Mali. Critics and fans alike warmly received

it, and while Eisner was reaching a new young adult audience, many of his older adult fans also enjoyed *Sundiata*.

Fagin the Jew

At the end of the twentieth century, Eisner again chose to address issues of racism and social class, but eschewed his roots and took his story back a century further. He told *Bookselling This Week*, "Over a period during which I was researching popular European folktales, I became aware that many of our modern day stereotypes originated in early stories. This led me to trace the origin of Fagin, one of the enduring stereotypes of a villainous Jew, created by Charles Dickens in *Oliver Twist*. It attracted my attention because this book has become a children's classic." Dickens didn't really provide a backstory for Fagin, so Eisner chose to do so in *Fagin the Jew* (2003). "I wanted to fill in his story, to show that his life paralleled Oliver Twist's in many ways," Eisner told the *Miami Herald-Tribune*. "The danger is when you use stereotyping for evil purposes." For Italian radio listeners, he elaborated on the work's genesis:

> I began to understand . . . that in these [European] folktales the villains or the characters were referred to ethnically. Like, he was an Italian? They referred to somebody as "the Italian" or something, throughout the whole book, and stopped using his name. Or they were saying "the nigger." And I somewhat became aware of the fact that we are exposed to

stereotypes created by another. This has an effect on our entire ethic.

You see, this medium—sequential art—depends on stereotypes as part of its language, so we create images that look like people that we want people to understand.

Eisner more formally discovered this visual stereotyping after working with his college students. Whenever he would ask them to draw a picture of a doctor, for example, most of them would draw a man in white with

a mustache, glasses, and a reflector on his head. Even though doctors come in all ages, ethnic backgrounds, and in both sexes, kids most often drew the same person. Although nobody imagines that all doctors look alike, we all have a stereotype of what a doctor looks like. In the same Italian interview, Eisner remarked:

I discovered that to my amazement [Dickens] began to refer to Fagin as "the Jew" throughout the book, without referring to anybody else in a [stereotypical way]. Then I began doing some necessary research and I discovered that at that time, 1740, the Jews [who] immigrated into England were a specific type of Jews. The caricatures were all wrong and they created a character that actually didn't really exist. It's the same that's happening in our country now with Mafia and Italian gangsters; gangsters are usually Italian in American storytelling, which is not fair, but the point is we have created stereotypes which embed themselves almost like a virus in our intellectual body.

Remember that, when we write . . . in the business of communication, we have to deal with the psyche of the times. So, when I'm writing about a black, and I'm trying to create humor in 1929, in America, that humor will be based on a person's inability to speak English properly. Or that he looks physically different, coming from a rural point of the country. Today, in year 2004, you can't do that anymore. It's no longer considered funny or socially correct, if you will, to have somebody be laughed at because he can't speak English well.

THE EISNER AWARDS

Given his influence, there's little surprise that one of the two industry awards in the comic-book business is named the Will Eisner Comic Industry Awards. Every summer, the awards are presented, with Eisner in attendance, at San Diego's Comic-Con International, the oldest convention for comics fans in America.

The awards, which were first handed out in 1988, have grown to accommodate over two dozen categories recognizing superior work from the previous year. The categories include the obvious Best Writer and Best Artist awards, but also look at Best Short Story, Best Graphic Album, and the best publications representing older works or covering the field itself.

Nominees are selected from a committee, which changes every year, reviewing submissions from publishers around the world. People throughout the comic-book field, writers, artists, and other creators; publishers; editors; and retailers and distributors then vote on the finalists.

It was fitting that, in 2001, Eisner himself took home a prize with DC Comics's *The Spirit Archives* winning for Best Archival Collection/Project.

[T]he times have an effect on how you write.
The function of the writer is to communicate with
the reader and deal with what he creates and
capture the reader's attention and create an
understanding between the two, between the
reader and the writer. So, in writing we use . . . a
common memory.

The Plot

The issue of stereotypes and Eisner's Jewish heritage
have not strayed from Eisner's mind. In 2005, Eisner
released another graphic novel, again drawn from his-
tory—but European history. The *Plot* explores the
1903 document, the *Protocols of the Elders of Zion*, a
historically noteworthy Russian forgery that purported
to be the Jews' secret plan to rule the world, indulging
people's worst stereotypes and fears.

"I was surfing the Web one day when I came
across this site promoting *The Protocols* to readers in
the [Middle East]," Eisner told the *New York Times*. "I
was amazed that there were people who still believed
The Protocols were real, and I was disturbed to learn
later that this site was just one of many that promoted
these lies in the Muslim world. I decided something
had to be done."

Eisner worked with University of Massachusetts,
Amherst, graphic novel teacher N. C. Christopher Couch
to research the truth behind the forgery. They, in turn,
were aided by French comics fan Benjamin Herzberg.

Their work explored the efforts of Mathieu Golovinski, who created twenty-four documents, said to be the minutes of meetings held by Jewish leaders. The hoax was first revealed by the *Times of London* in 1921, pointing out the similarity between *Protocols* and a satire by the French writer Maurice Joly from 1864.

In a unique blending of Eisner's disciplines, the *Plot* has three sections: an introduction regarding Eisner's research into the *Protocols*; a graphic retelling of their existence and ultimate exposure; and a historic section comparing Joly's writing with Golovinski's. He told the *Times*, "The great irony of *The Protocols*'s continued existence is that they were proven to be false as early as 1921. I wanted to create a work that would be understood by the widest possible audience."

Eventually, Eisner closed up the studio and retired from teaching in 1993. He then relocated with his wife, Anne, and brother Pete to Florida, set up offices in a medical building, and continued to produce new works. Pete archived Eisner's artwork, helping to provide art and stories to eager publishers around the world. Pete passed away in early 2004, but Eisner continued to forge ahead with new work.

Eisner recognized there would not be enough time to tell every story he wanted or revisit every character he created. In 2004, he licensed his short-lived *John Law* to IDW Publishing. Writer and artist Gary Chaloner produced several new stories that also featured Lady Luck, Mr. Mystic, and Nubbin, in addition to reprinting Eisner's original stories. The single-volume black-and-white collection was well-received.

In this 2001 photograph, Eisner holds the famous award that bears his name. The Will Eisner Awards are given out annually to cartoonists whose works are judged superior by a panel of their peers. The Eisner awards are considered "the Oscars of the industry"; they are handed out personally by Eisner himself every year in a gala ceremony at Comic-Con International, the largest and oldest comic convention in the United States.

Eisner regards 2003 as one of his most accomplished years to date. Instead of just retelling a story, he is now using the comic medium to take an intellectual stand. With the graphic novel now the subject of much media attention, the comics medium is stronger and livelier than ever. Rather than just last-minute impulse purchases at supermarkets as they had been in earlier years, comic

books and graphic novels now have entire sections devoted to them in bookstores and public libraries.

"I believe this medium is the new literacy in this country. Words themselves are not able to keep up with the speed of information. This combination of words and images will continue to grow and it will dominate," Eisner said in an interview on Miami.com (http://www.miami.com). With that in mind, he told listeners in Italy:

Well, the medium itself is well-established, that is its capacity to deal with a subject matter beyond the ordinary superheroes stories. [My] current book, *Fagin the Jew*, is an attempt to find a new direction, what we call a polemic, which is using this medium to make an intellectual point. That was the purpose, I think. I'm still involved in trying to be at the head of the parade, you know; I'm an exploratory man. I still feel like that. There's so much yet to do that I really can't pay attention to the fact that I'm older than I was.

The Building. Princeton, WI: Kitchen Sink Press, 1987; New York: DC Comics, 2000.

City People Notebook. Princeton, WI: Kitchen Sink Press, 1989; New York: DC Comics, 2000.

A Contract with God and Other Tenement Stories. New York: Baronet Press, 1978; Princeton, WI: Kitchen Sink Press, 1985, with an introduction by Dennis O'Neil; New York: DC Comics, 2000.

The Dreamer. Princeton, WI: Kitchen Sink Press, 1986; New York: DC Comics, 2000.

Dropsie Avenue: The Neighborhood. Northampton, MA: Kitchen Sink Press, 1995; New York: DC Comics, 2000.

Fagin the Jew. New York: Doubleday, 2003.

Family Matter. Northampton, MA: Kitchen Sink Press, 1998.

Hawks of the Seas, 1936–1938. Introduction by Al Williamson. Edited and with an afterword by Dave Schreiner. Princeton, WI: Kitchen Sink Press, 1986; Milwaukie, OR: Dark Horse Comics, 2003.

Invisible People. Princeton, WI: Kitchen Sink Press, 1993; New York: DC Comics, 2000.

Last Day in Vietnam: A Memory. Milwaukie, OR: Dark Horse Comics, 2000.

The Last Knight: An Introduction to Don Quixote by Miguel de Cervantes. New York: Nantier, Beall, Minoustchine Publishing, 2000.

A Life Force. Princeton, WI: Kitchen Sink Press, 1988; New York: DC Comics, 2001.

Life on Another Planet. Introduction by James Morrow. Originally published as *Signal from Space*. Northampton, MA: Kitchen Sink Press, 1995; New York: DC Comics, 2000.

Minor Miracles. New York: DC Comics, 2000.

Moby Dick by Herman Melville. Retold by Will Eisner. New York: Nantier, Beall, Minoustchine Publishing, 2001.

The Name of the Game. New York: DC Comics, 2001.

New York, the Big City. Princeton, WI: Kitchen Sink Press, 1986; New York: DC Comics, 2000.

The Plot. New York: W. W. Norton, 2005.

The Princess and the Frog by the Grimm Brothers. Retold by Will Eisner. New York: Nantier, Beall, Minoustchine Publishing, 1999.

Signal from Space. Princeton, WI: Kitchen Sink Press, 1983.

The Spirit Archives volumes 1–16. New York: DC Comics, 2000–2004 (projected to 24 volumes).

Sundiata: A Legend of Africa. Retold by Will Eisner. New York: Nantier, Beall, Minoustchine Publishing, 2003.

To the Heart of the Storm. Princeton, WI: Kitchen Sink Press, 1991; New York: DC Comics, 2000.

Eisner Award
Best Graphic Album (The *Name of the Game*, 2002)
Best Archival Collection/Project (*The Spirit Archives*
 volumes 1 and 2, 2001)
Best Comics-Related Book (*Graphic Storytelling*, 1997)
Best Archival Collection/Project (The *Christmas Spirit*, 1995)
Best Graphic Album (*To the Heart of the Storm*, 1992)

Harvey Award
Best Graphic Album (*Last Day in Vietnam,* 2001)
Best Domestic Reprint (*The Spirit Archives*, 2001)
Best Writer (*Invisible People,* 1993)
Best Cartoonist (*Invisible People*, 1993)
Best Graphic Album (*To the Heart of the Storm*, 1992)

Jack Kirby Hall of Fame Award (1987)

National Cartoonists' Society Reuben Award

National Federation for Jewish Culture Award

San Francisco Museum of Cartoon Art Sparky Award, 2001

Special Lifetime Achievement Award, 2002

GLOSSARY

artist The person responsible for creating the artwork for the given assignment. This title is usually reserved for a single person who has done the complete artwork.

dialogue The words spoken by the characters.

editor A person responsible for every aspect of a comic, from approving the plot to overseeing assignments, artwork, cover and ad copy, proofreading, production, and printer proofs.

graphic novel A work in excess of forty-eight pages that tells a self-contained story. Current use implies that subject matter is of a more mature nature and usually the vision of one or two creators. The term is also applied to collected works, such as a series of monthly comics making up one story.

inker The artist who uses black ink to complete a penciller's artwork, readying it for reproduction. The inker brings some of his or her own talent to the page and is also relied upon to make minor corrections.

letterer The artist who uses black India ink and various tools to add the words, balloon shapes, sound effects, and panel borders to the page. This step is usually done between pencilling and inking.

page rate The amount paid for a given task. Rates vary by discipline, experience, and talent.

penciller The penciller tells the story in visual form, determining the page and panel composition that best allows the reader to follow the story. This includes figures, backgrounds, light sources, clothing, architecture, etc.

plot The synopsis or summary of the story, providing the artist with all the details necessary to illustrate the story.

publisher The person who actually pays the talent, staff, and printer, determining the look, feel, and consistency of a company's output.

pulp magazine Cheap fiction magazines, usually dedicated to a subject such as science fiction or private detectives. Named "pulps" because of the newsprint on which they were published, the cheapest kind of paper available for printing, usually with painted lurid covers. Prior to the paperback book, these were hugely successful between the 1920s to 1950s.

script Similar to a movie script, a comic-book script breaks a story down into individual pages, describing the action for each panel and what words and captions are required.

Sunday page An entire section of the Sunday newspaper edition devoted to comic strips. The Sunday page allows the artist greater room for visual presentation or a longer part of a serialized story. Originally, Sunday features had a half or a whole page of the section. Today, features fight for space and are rammed four to five to a given page depending on their sizes.

word balloon The space devoted to the words spoken by individual characters in a comic story.

writer The person responsible for composing a story given the number of pages assigned. The writer tells the story, in the form of a plot or script, with a clear beginning and ending, providing the visual details and emotions required to effectively communicate to the reader.

FOR MORE INFORMATION

New York City Comic Book Museum
P.O. Box 230676
New York, NY 10023
(212) 712-9454
e-mail: nyccbm@hotmail.com
Web site: http://www.nyccomicbookmuseum.org

Web Sites

Due to the changing nature of Internet links, the
Rosen Publishing Group, Inc., has developed an online
list of Web sites related to the subject of this book.
This site is updated regularly. Please use this link to
access the list:

http://www.rosenlinks.com/lgn/wiei

FOR FURTHER READING

Chabon, Michael. *The Amazing Adventures of Kavalier & Clay.* New York: Picador USA, 2001.

Couch, N. C. Christopher, and Stephen Weiner. *The Will Eisner Companion.* New York: DC Comics, 2004.

Eisner, Will. *Comics & Sequential Art.* Tamarac, FL: Poorhouse Press, 1985.

Eisner, Will. *Graphic Storytelling.* Tamarac, FL: Poorhouse Press, 1996.

Eisner, Will. *Will Eisner's Shop Talk.* Milwaukie, OR: Dark Horse Comics, 2001.

Eisner, Will, and Frank Miller. *Eisner Miller.* Milwaukie, OR: Dark Horse Comics, 2004.

McCloud, Scott. *Understanding Comics.* New York: DC Comics, 1994.

BIBLIOGRAPHY

Benton, Mike. *The Comic Book in America*. Dallas, TX: Taylor Publishing Company, 1989.

Eisner, Will. *Hawks of the Seas, 1936–1938*. Introduction by Al Williamson. Edited and with an afterword by Dave Schreiner. Princeton, WI: Kitchen Sink Press, 1986; Milwaukie, OR: Dark Horse Comics, 2003.

Eisner, Will. *Shop Talk*. Milwaukie, OR: Dark Horse Comics, Inc., 2001.

Feiffer, Jules. *The Great Comic Book Heroes*. New York: The Dial Press, 1965.

Gifford, Denis. *The International Book of Comics*. New York: Crescent Books, 1984.

Goulart, Ron. *Over 50 Years of American Comic Books*. Lincolnwood, IL: Mallard Press, 1991.

Horn, Maurice. *The World Encyclopedia of Comics*. New York: Chelsea House, 1976.

Jones, Gerard, and Will Jacobs. *The Comic Book Heroes*. New York: Prima Publishing, 1997.

Steranko, Jim. *The Steranko History of Comics* volume 2. Reading, PA: Supergraphics, 1972.

Yronwode, Catherine. *The Art of Will Eisner*. Princeton, WI: Kitchen Sink Press, 1982.

INDEX

Acknowledgments

Special thanks to Denis Kitchen for his kindness and generosity regarding this book and series.

About the Author

Robert Greenberger has worked most of his adult life in comics after growing up reading them since early childhood. He is currently a senior editor at DC Comics in the collected editions department. Additionally, he writes fiction (mainly *Star Trek*) and nonfiction on a variety of topics. He makes his home in Connecticut with his wife, Deb, and children, Katie and Robbie.

Credits

Cover (photo) © AP/Wide World Photos; cover (comics panels), title page, pp. 3, 72 © Will Eisner Studios, Inc., pp. 5, 48 Will Eisner Collection, the Ohio State University Cartoon Research Library; p. 8 Library of Congress Prints and Photographs Division; p. 11 Frank Vincent DuMond Class with Model in Costume, ca. 1930s, archives of the Art Students League of New York; p. 16 Library of Congress Prints and Photographs Division, © reprinted with special permission of King Features Syndicate; p. 20 © 1986 Will Eisner Studios, Inc.; pp. 34, 55, 67 courtesy Denis Kitchen Art Agency; p. 36 Library of Congress Prints and Photographs Division, Copyright, Tribune Media Services, Inc. all rights reserved, reprinted with permission; pp. 39, 44, 58, 60 ©/™ Will Eisner Studios, Inc.; p. 51 © Elliot Fine, courtesy Alter Ego; p. 70 © 1966 Will Eisner Studios, Inc.; p. 75 © 1983 Denis Kitchen; p. 80 © 1978 Will Eisner Studios, Inc.; p. 85 © 1995 Will Eisner Studios, Inc.; pp. 89, 91 © 1987 Will Eisner Studios, Inc.; p. 94 From FAGIN THE JEW by Will Eisner, copyright © 2003 by Will Eisner, used by permission of Doubleday, a division of Random House, Inc.; p. 99 courtesy of Comic-Con International, San Diego.

Designer: Les Kanturek; Editor: Joann Jovinelly